3rd Annual Invitational
June 25 - July 13, 2019

noho M55 gallery

530 West 25th Street 4th floor New York, NY 10001

INTRODUCTION

Members of 55 Mercer Street Gallery and Noho Gallery have traditionally invited guest artists to exhibit in our spaces, and since our Chelsea partnership in 2013 this is our third combined member-guest invitational.

It is an honor and privilege to open our gallery to fellow artists and one of the benefits of an artist-run organization. This year 24 members and 35 guests make up the 59-artist exhibition. The gallery has invited guests recommended by our members, sight unseen. There is no curator or theme other than the members' recommendations of artists whose work they personally respect. We value their judgment and that's what makes such an exhibition possible. Over the years these member-guest interactions have both surprised and inspired us.

Noho M55 Gallery thanks all of our guest artists for participating in this 3rd Annual Invitational.

–Annette Morriss, President, M55 Art
–Leon Yost, President, Noho Gallery

Contents

Arlene Baker 7
Deborah L. Brand 8
Stacy Bogdonoff 9
Mario Busoni 10
Benedicte Caneill 11
Suzan Courtney 12
Julia Eisen-Lester 13
Pat Feeney Murrell 14
Elaine Forrest 15
Jessica Fromm 16
Marie-Noelle Gagnan 17
Karen Gentile 18
Ray Germann 19
Janet Glazer 20
Marilyn Henrion 21
Deborah Holcombe 22
Malka Inbal 23
Angelo Jannuzzi 24
Robert Jessel 25
Laurie Karp 26
Maryann King 27
Elizabeth Kresch 28
Deborah Kriger 29
Carole Kunstadt 30
Amanda Lawford 31
Lisa Lackey 32
Elaine Longtemps 33
Juliet Martin 34
Erma Martin Yost 35

Alfred Martinez 36
Janice Mauro 37
Stephen McKenzie 38
Gail Miller 39
Chuck Miley 40
Fritzner Mervilus 41
Mark V. Mellinger PhD 42
Annette Morriss 43
Margot Olejniczak 44
Joanne Pagano Weber 45
Ed Rath 46
Glenn Reed 47
Nicolette Reim 48
Gail Resen 49
Larry Rushing 50
Judy Russell 51
Larry Schulte 52
Donald Silverman 53
Harry Spitz 54
Melissa Starke 55
Emily Stedman 56
Margaret Vickers 57
Martine Villandre 58
Hiroko Wada 59
Kevin Wilson 60
Tony C. Wilkinson 61
Marcin Wlodarczyk 62
Saaraliisa Ylitalo 63
Leon Yost 64

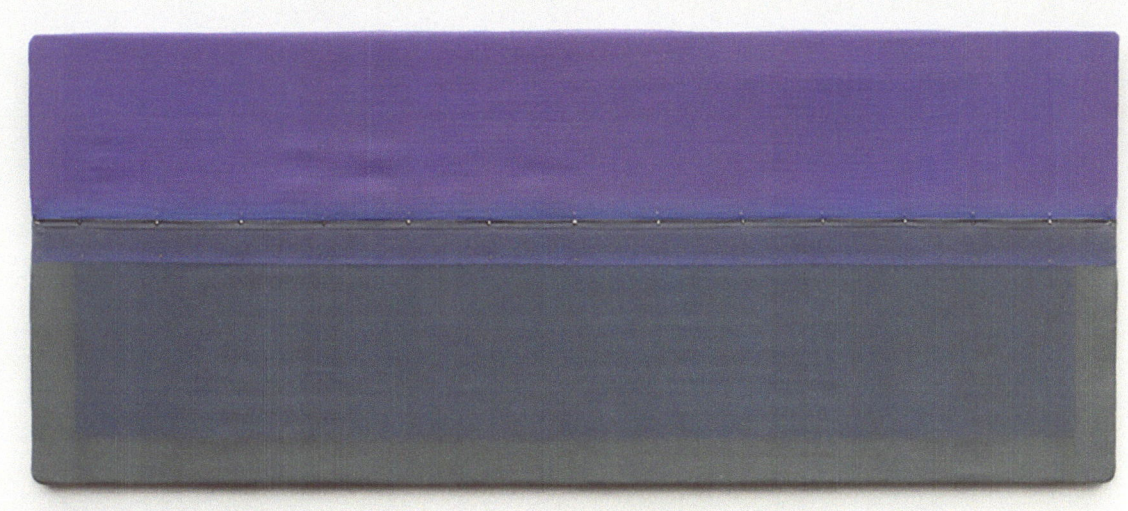

Arlene Baker

Silk Spaces # 278, 2013
Mixed media painting
8" x 20"

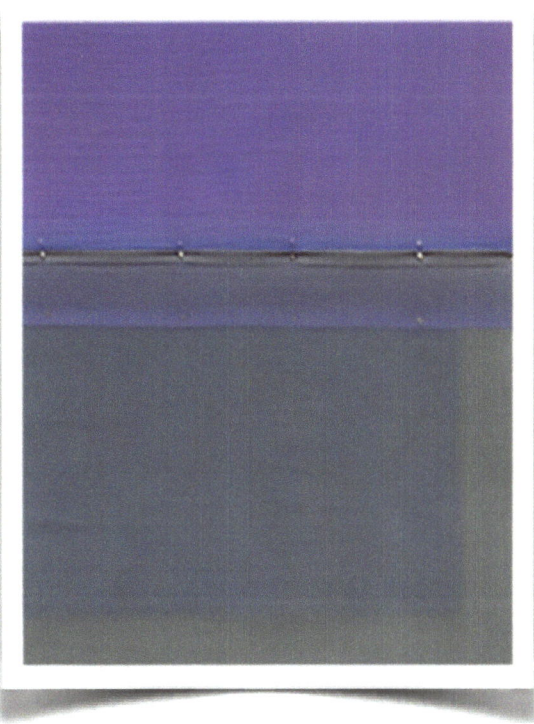

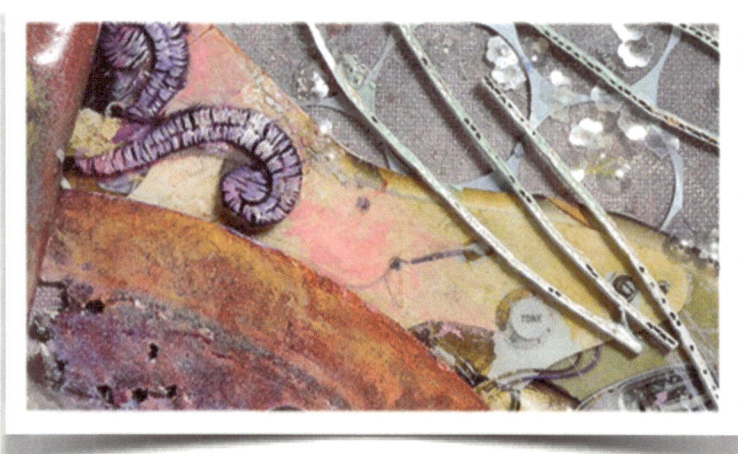

Deborah L. Brand

Cosmic Event, 2018
Steel, glass beads,
paper, paint on canvas
24" x 20" x 1.75"

Stacy Bogdonoff

Urban Hike, 2018
Digital print on fabric,
paper, silk thread
20" x 20"

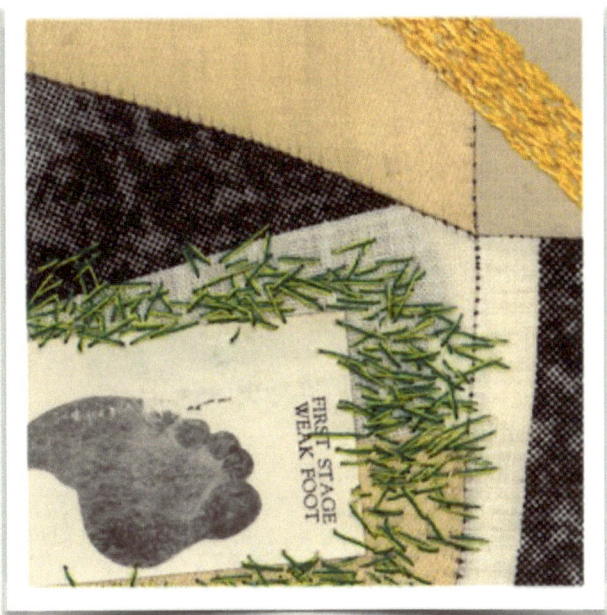

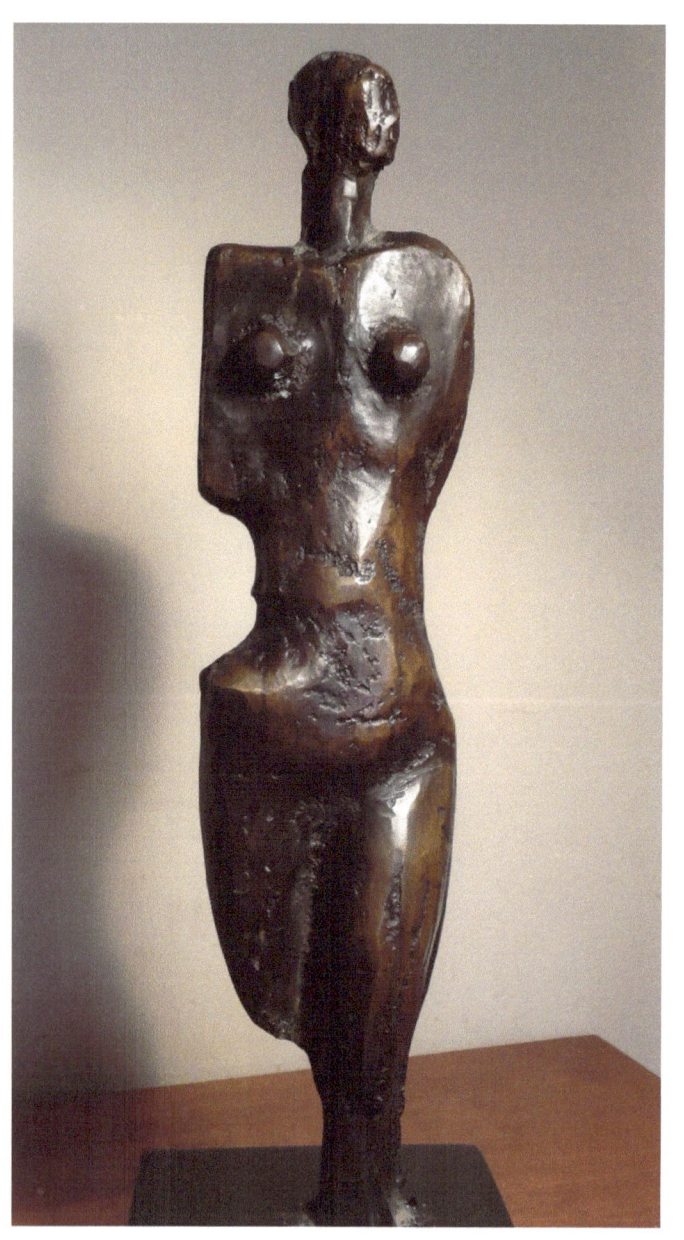
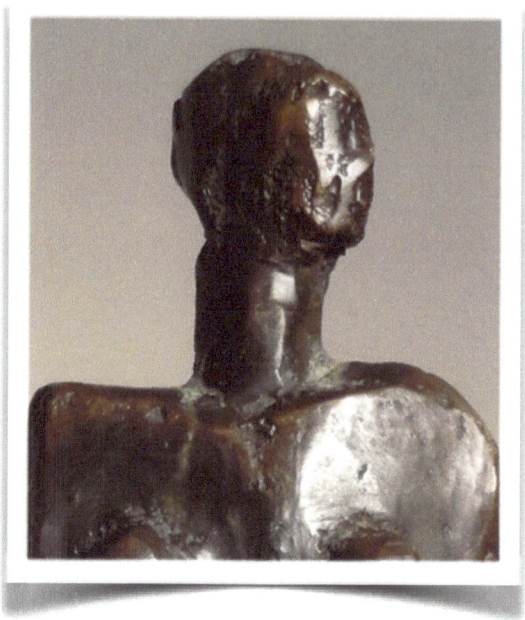

Mario Busoni

Standing Figure, 2014
Bronze
17" h

Benedicte Caneill

Winter Forest, 2013
Cotton fabric, textile paint, fabrics
monoprinted and assembled
by machine
12" x 12"

Suzan Courtney

Landscrape 1, 2018
Watercolor on paper
30" x 22"

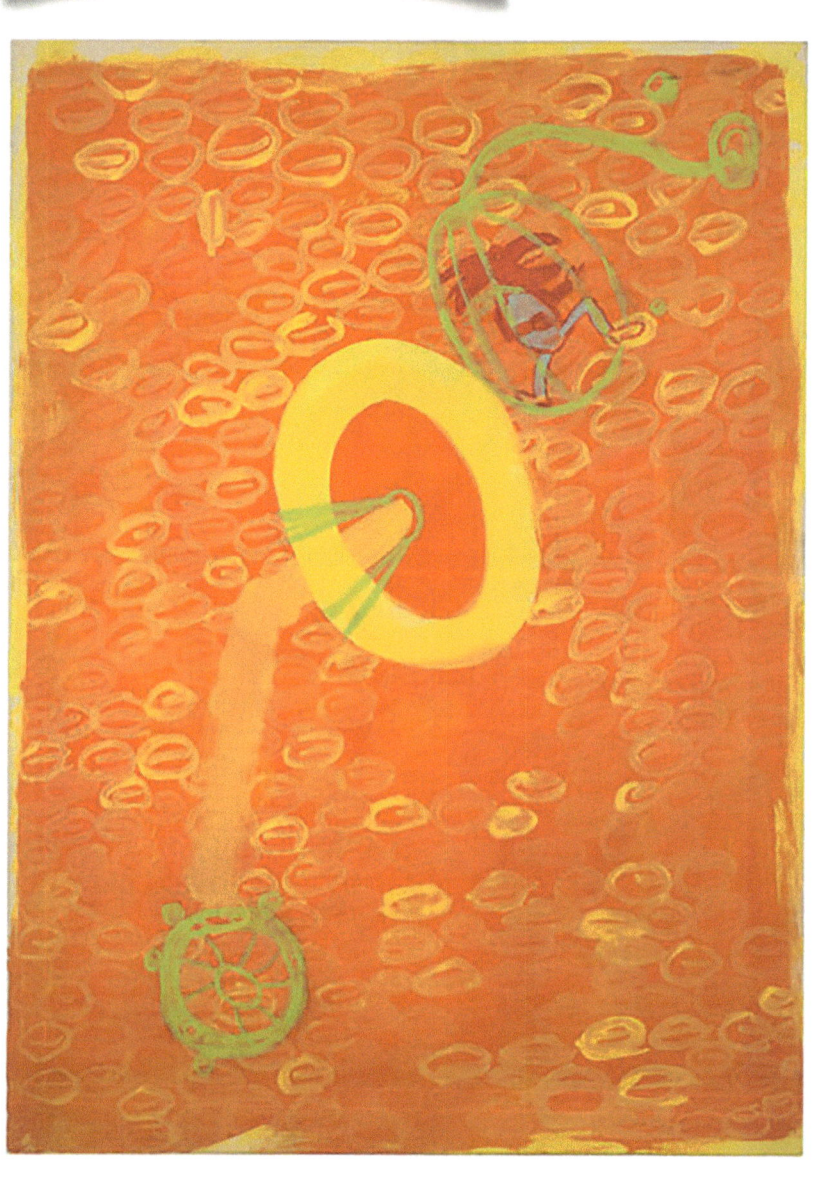

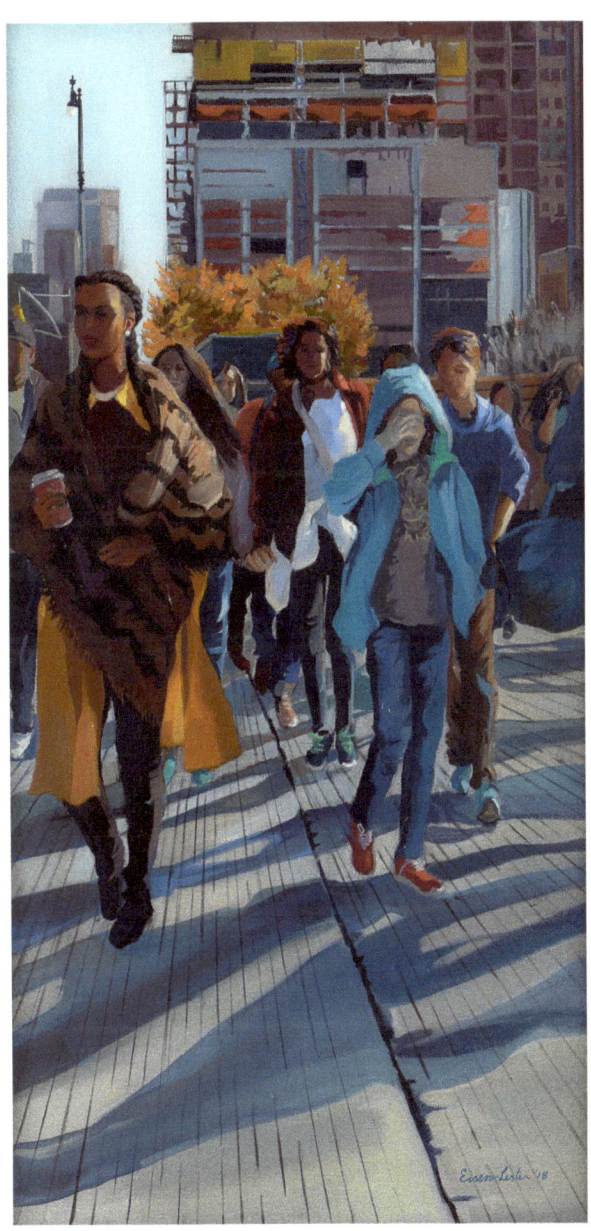

Julia Eisen-Lester

Pedestrian Onslaught, 2019
Oil on Canvas
24" x 12"

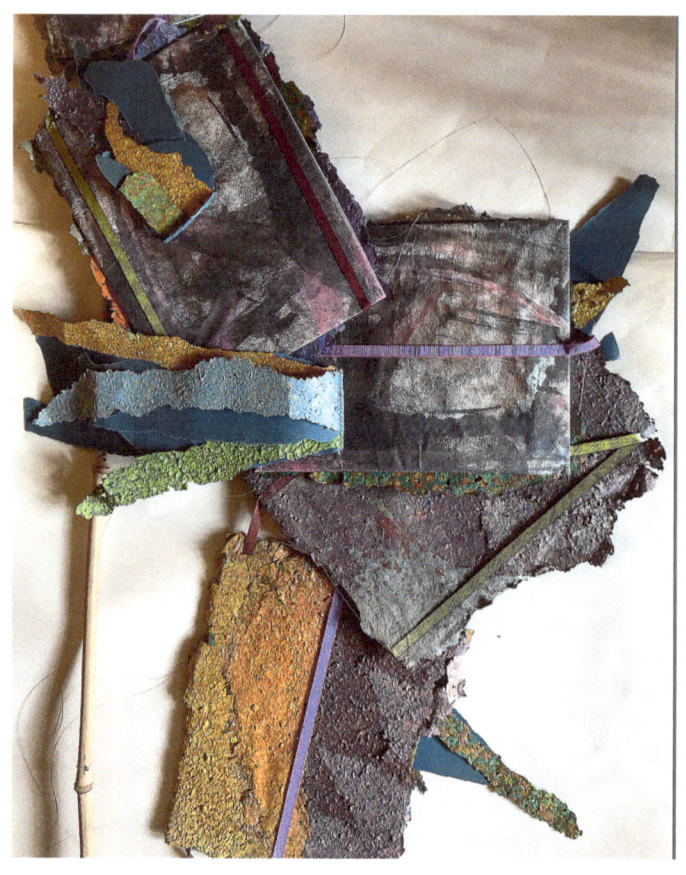

Pat Feeney Murrell

Endless, 2013
Jacob's Ladder Book, digital transfer monotype, flax handmade paper, ribbons, bamboo hanger
86" x 12" x 12"

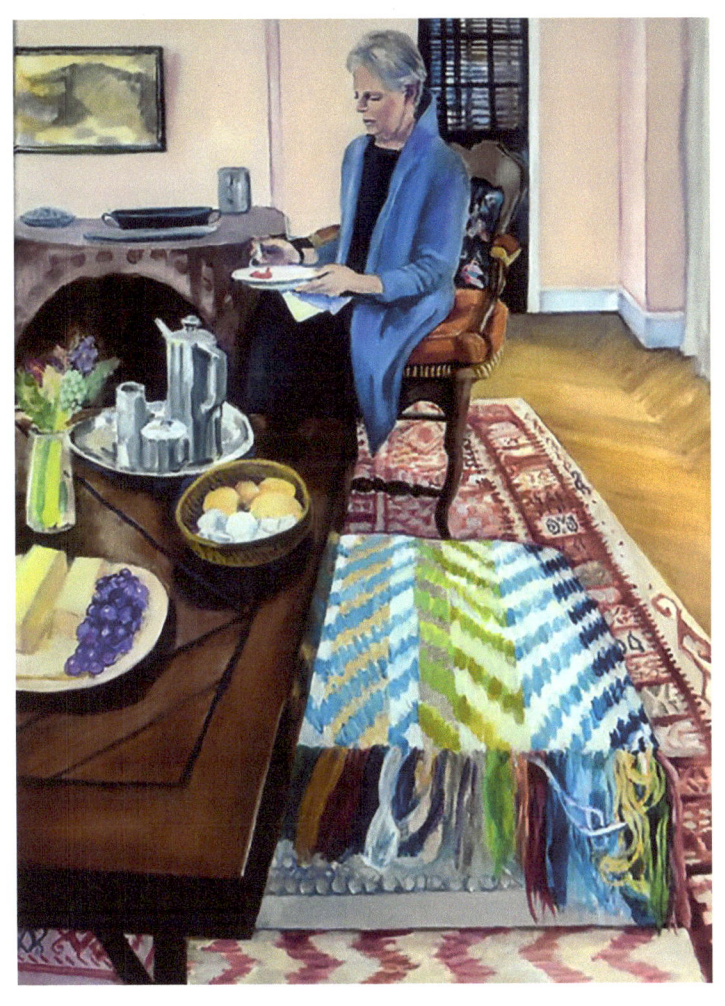

Elaine Forrest

NESSA, 2019
Oil on canvas
24" x 18"

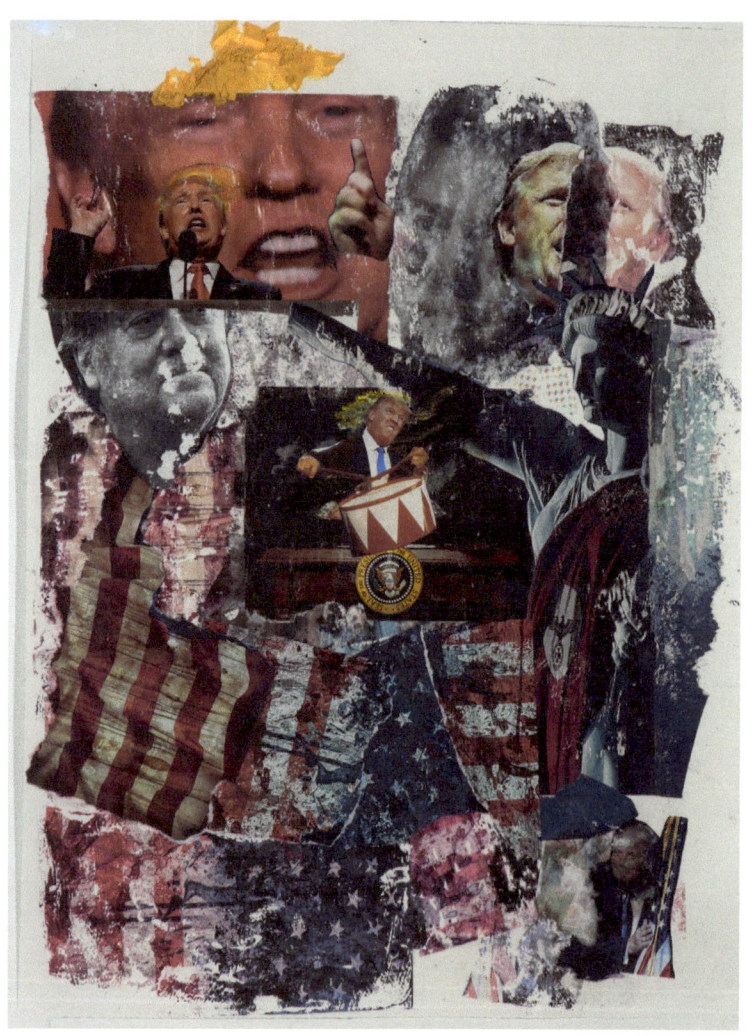

Jessica Fromm

Beat the Drum, 2017
Mixed media, collage on paper
23" x 19"

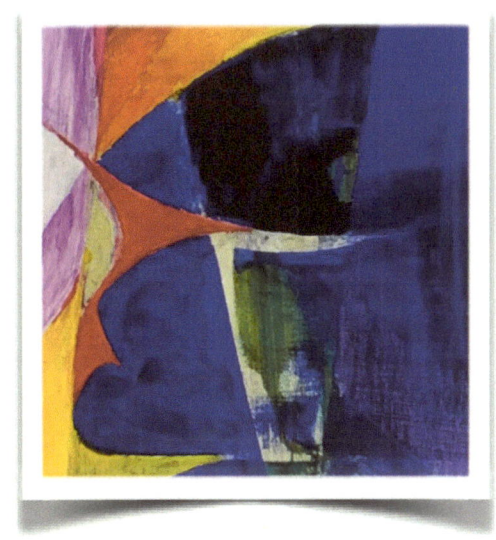

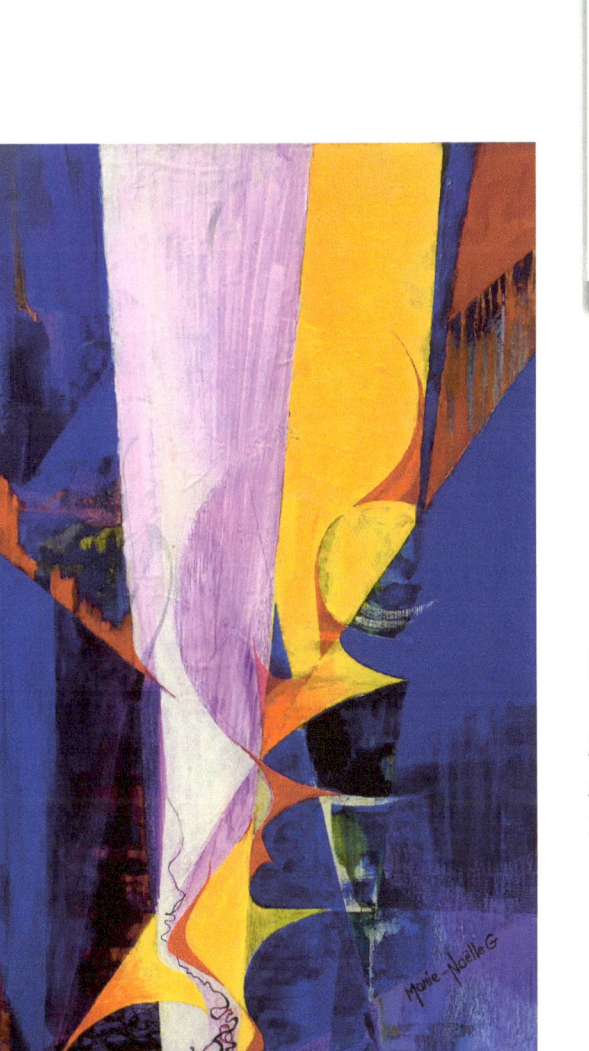

Marie-Noëlle Gagnan

Dénouement, 2017
Acrylic, oil pastel on canvas
36" x 24"

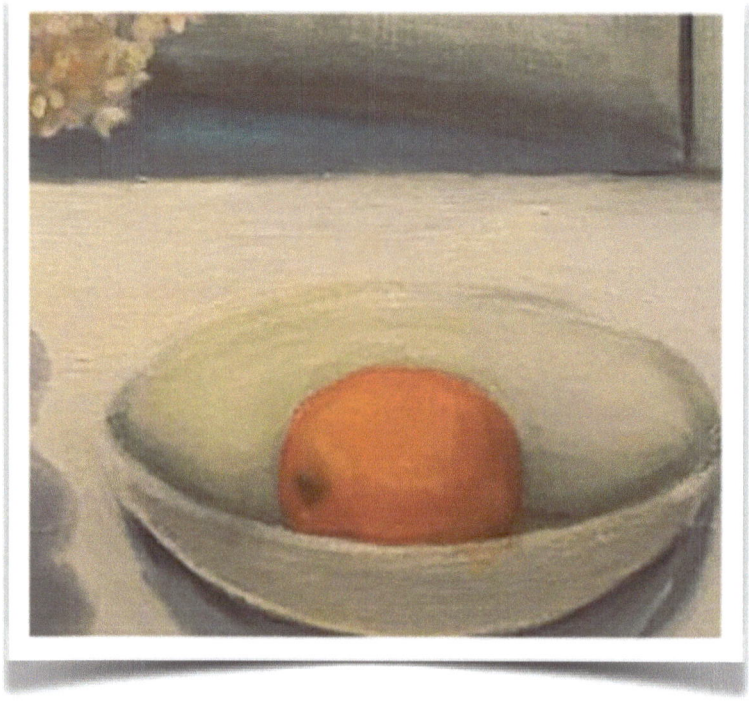

Karen Gentile

Still Life, 2018
Oil on linen
16" x 20"

Ray Germann

The Whitney Museum, 2015
Photography
16" x 20"

Janet Glazer

Metropolitan Museum Shadows, 2013
Photography
20" x 16"

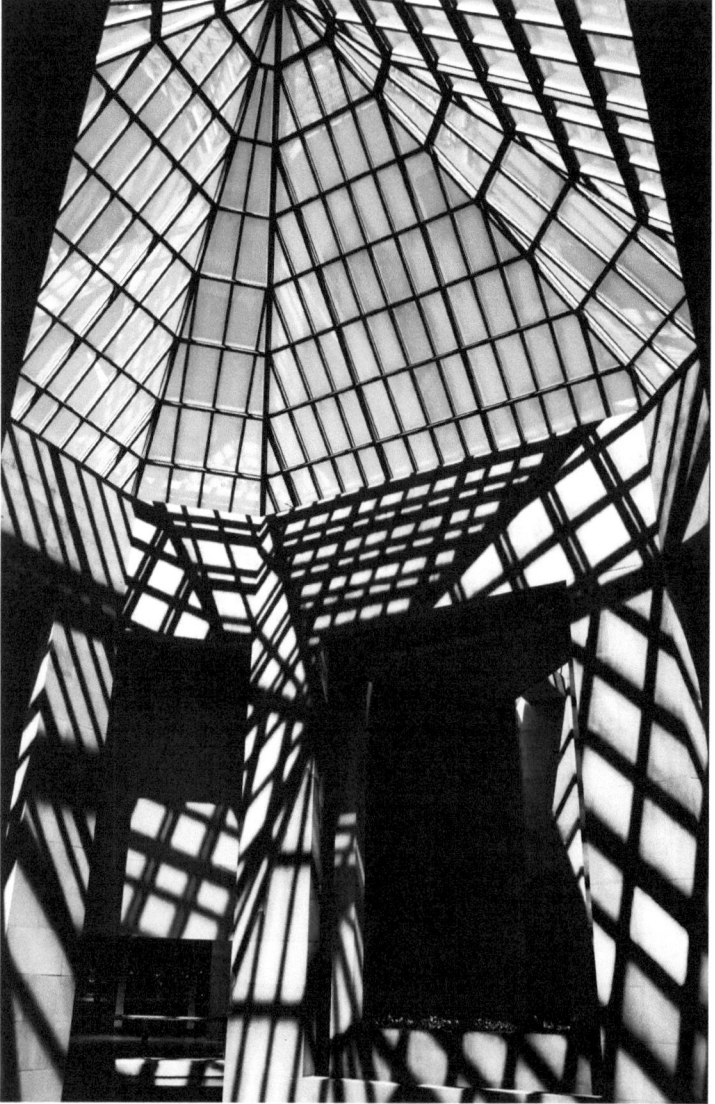

Deborah Holcombe

Carafe and Cord, 2019
Oil on canvas
40" x 16'

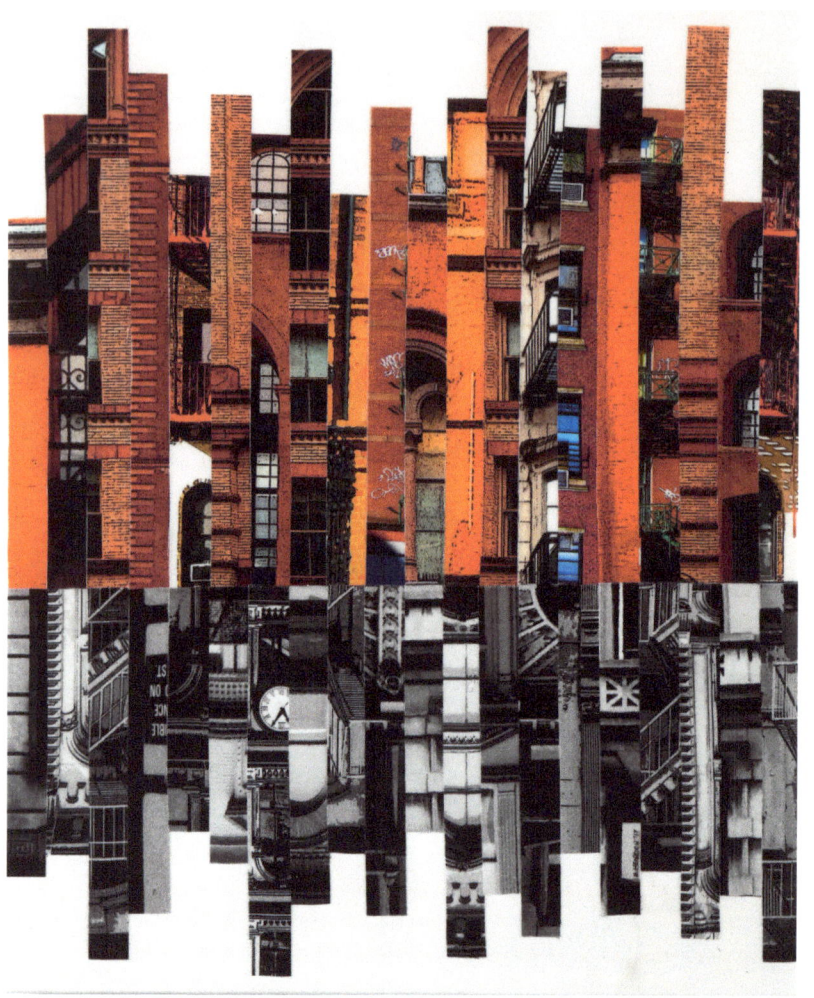

Marilyn Henrion

NYC Reflections, 2017
Linen collage on canvas
24" x 20"

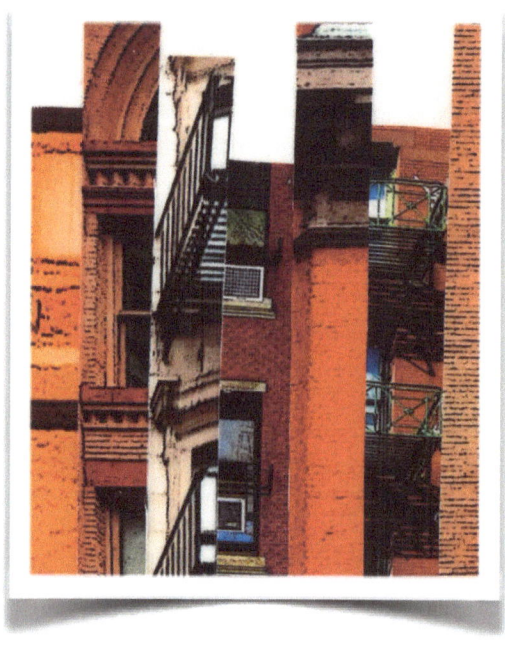

Malka Inbal

Untitled, 2015
Photograph
12" x 12"

Angelo Jannuzzi

Who Knows?, 2019
Collage
11" x 7.5"

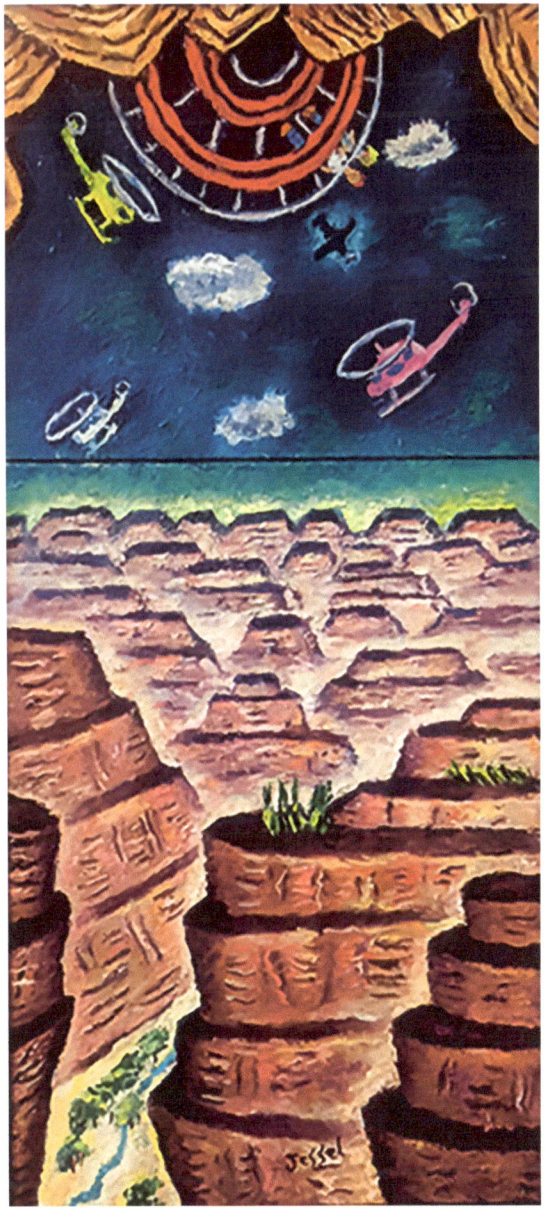

Robert Jessel

Grand Canyon, 2018
Oil on canvas
39" x 19"

Laurie Karp

Small Boy and Bear, 2002
Embroidery on digital image
11.5" x 11"

26

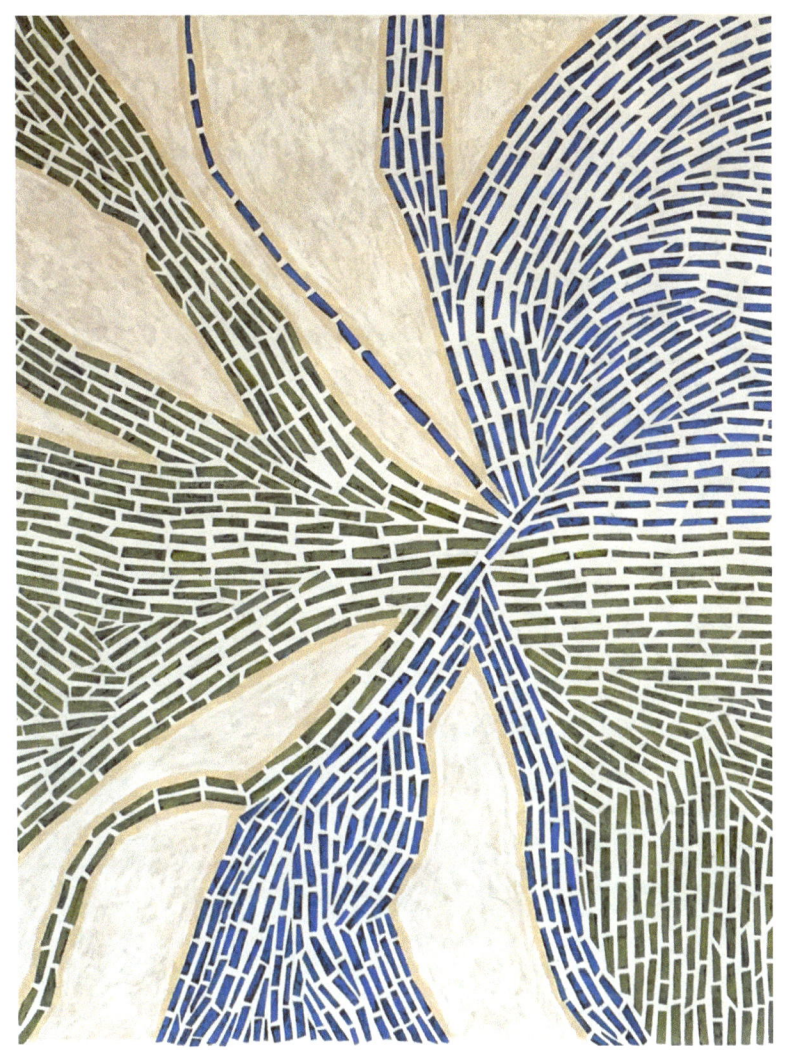

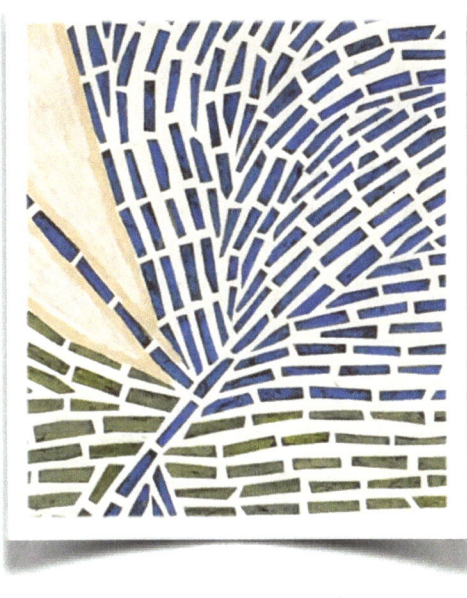

Maryann King

Untitled, 2019
Paper, acrylic paint
and matte medium on Tyvek
23.6" x 16'

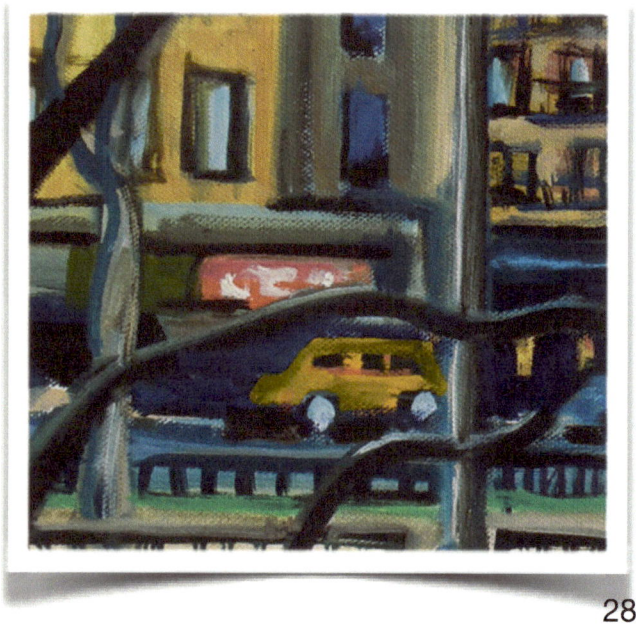

Elizabeth Kresch

Allen St., 2019
Oil on canvas
16" x 19"

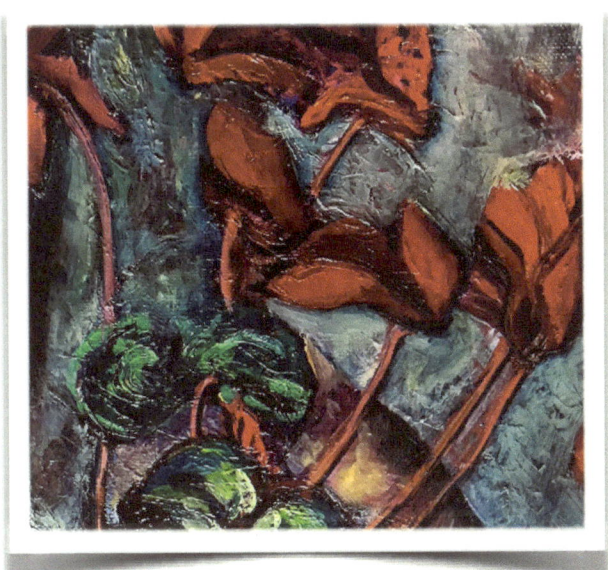

Deborah Kriger

Red Cyclamen, 2015
Oil on canvas
20" x 16"

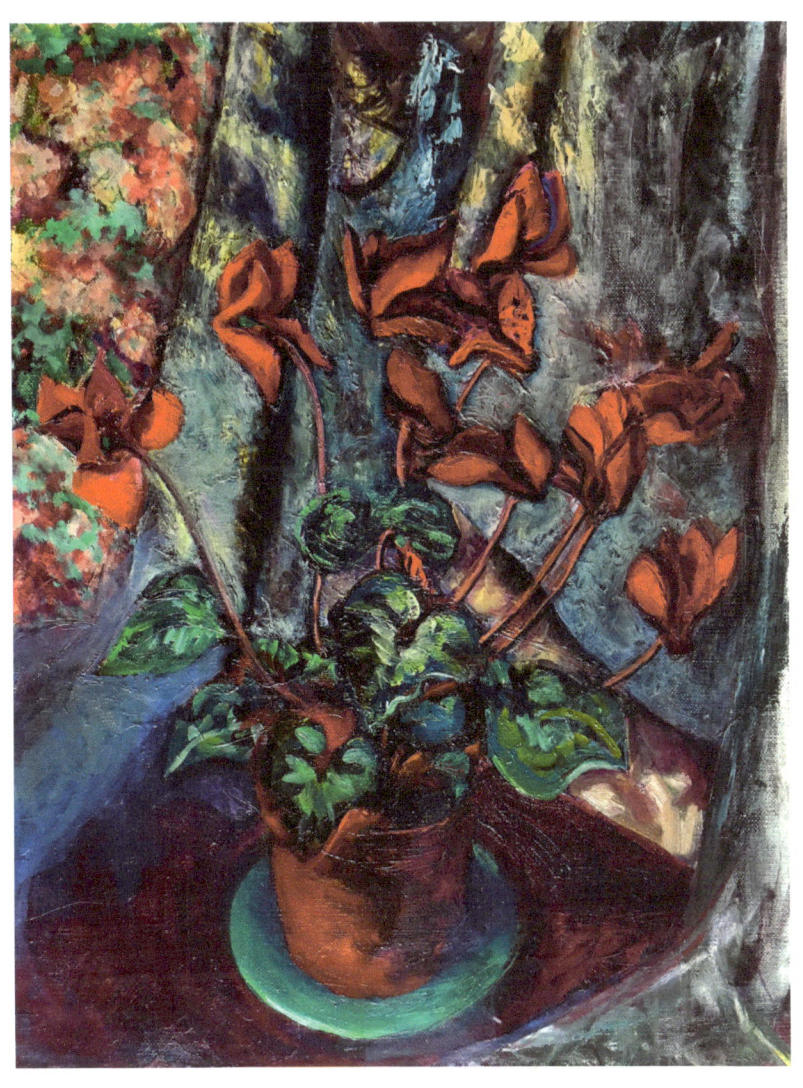

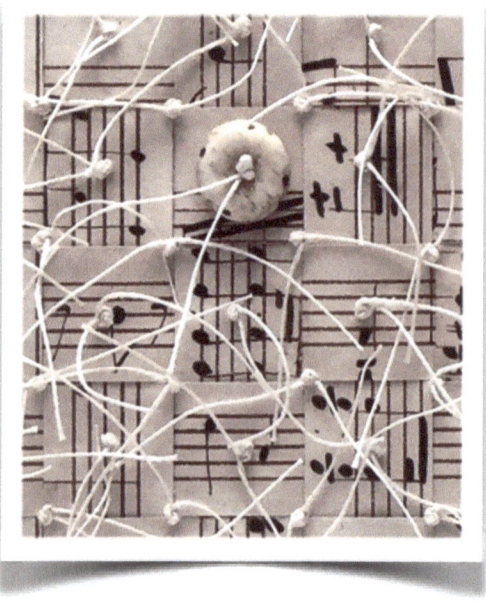

Carole Kunstadt

Interlude No.6, 2017
Linen thread, bone bead,
oak gall ink on paper:
19th C. Dantier - Paris music
manuscript
11.25" x 11.25" x 0.50"

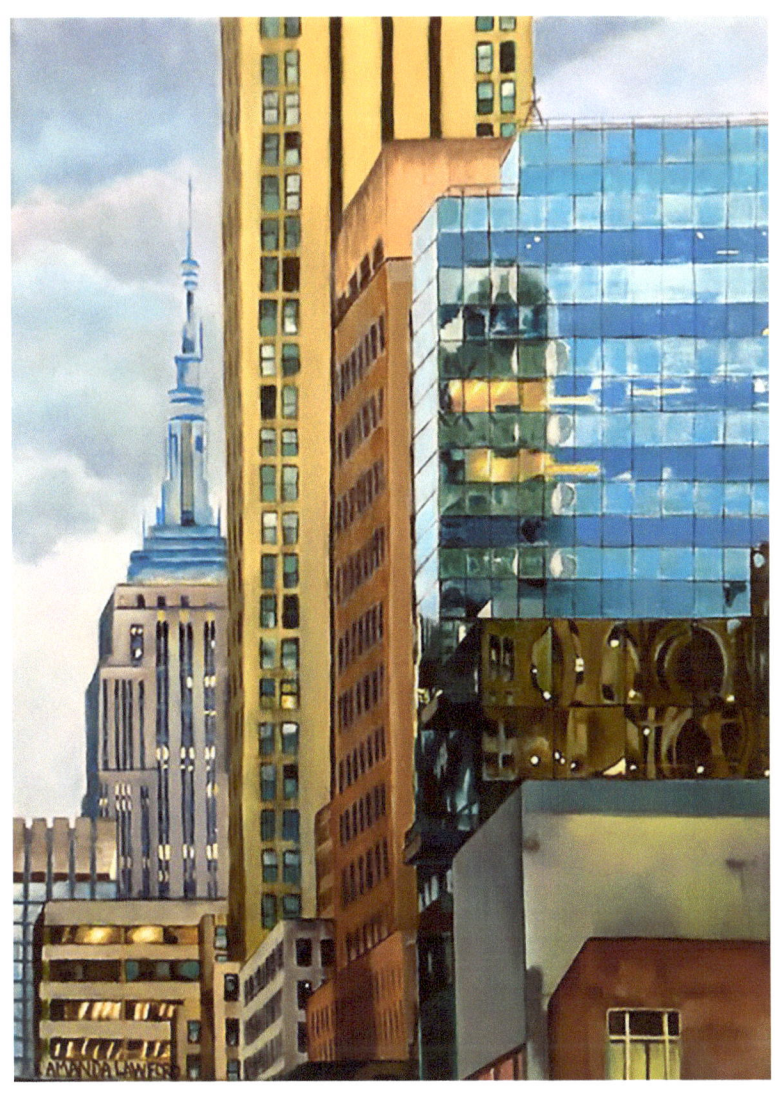

Amanda Lawford

Twilight, 2019
Acrylic on Canvas
16" x 12"

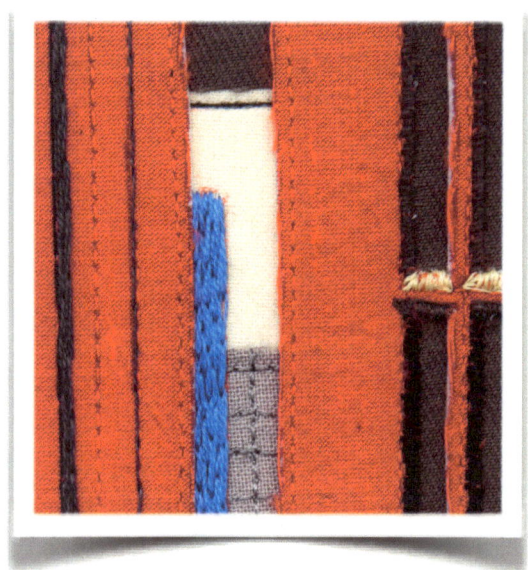

Lisa Lackey

MS839: UP, 2016
Fabric and thread on canvas
16" x 16"
Photo credit: Jean Vong

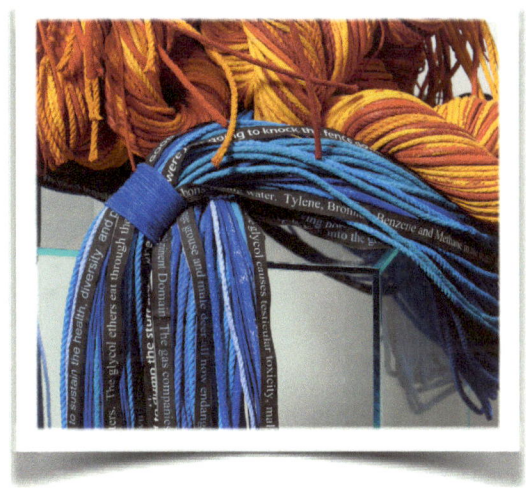

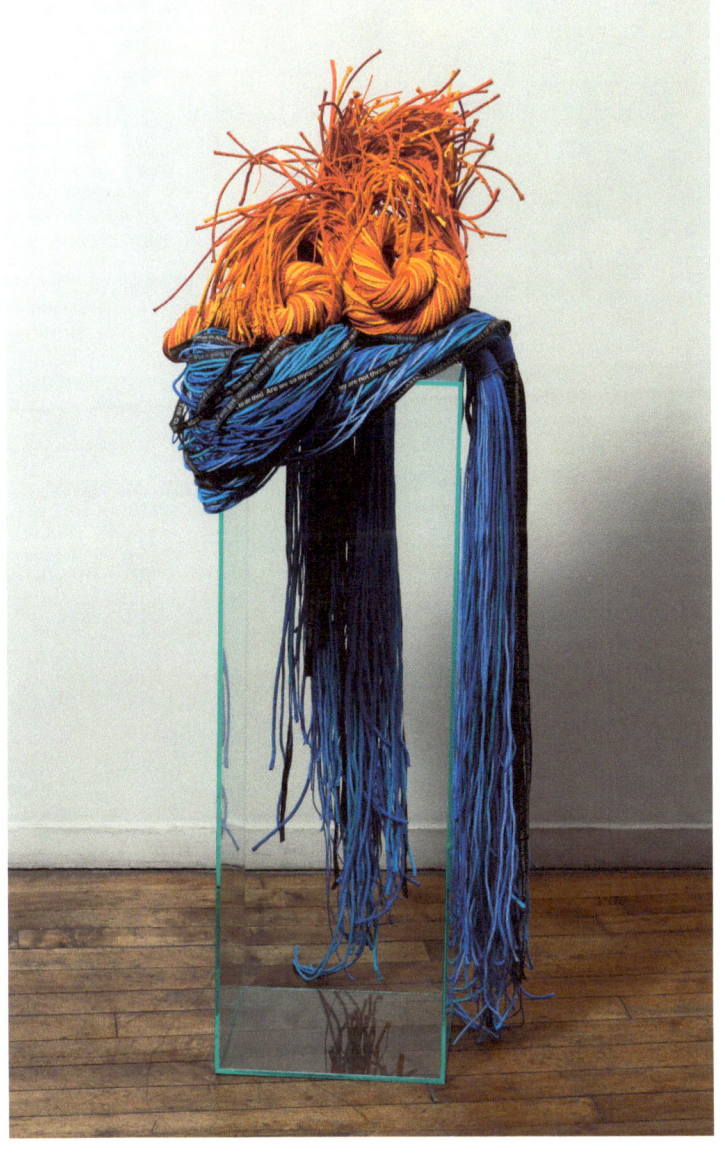

Elaine Longtemps

Fire From Water
(or Fracking America), 2011
Painted rope, digital printing on cotton
59" x 19" x 18"

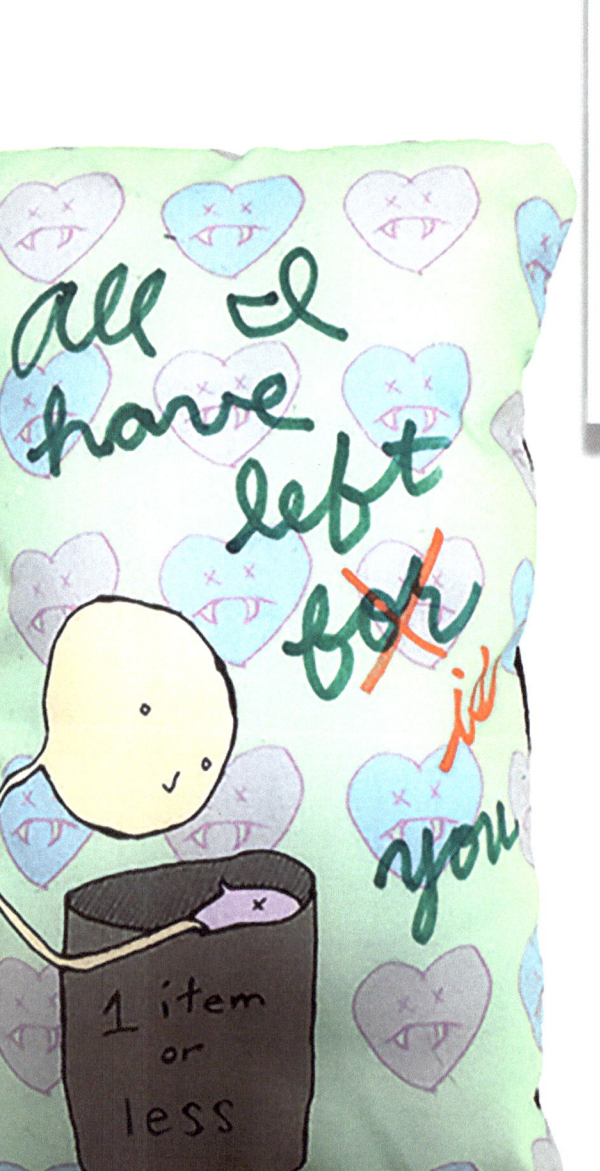
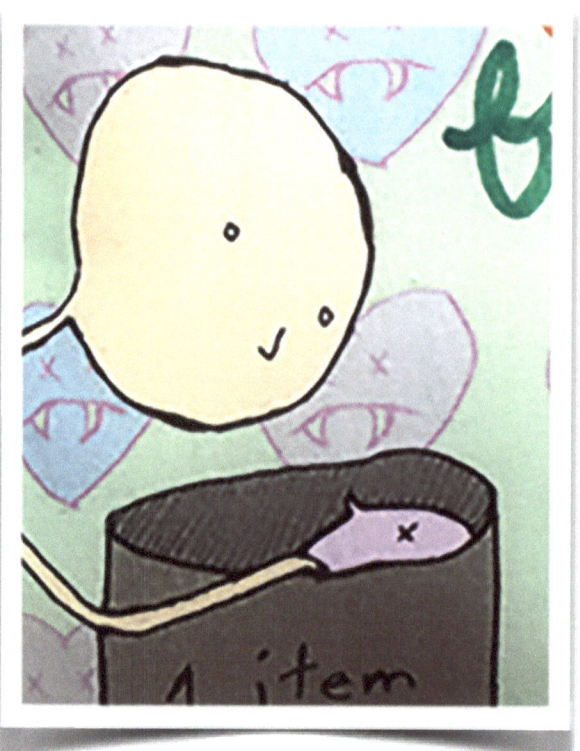

Juliet Martin

1 Item or Less, 2018
Fiber
6" x 4"

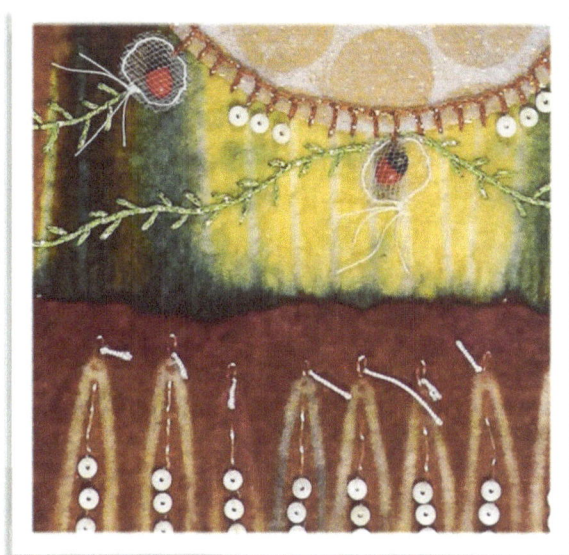

Erma Martin Yost

Seed Shrine, 2019
Hand-felted, resist-dyed, stitched construction
21" x 18" x 2.5"

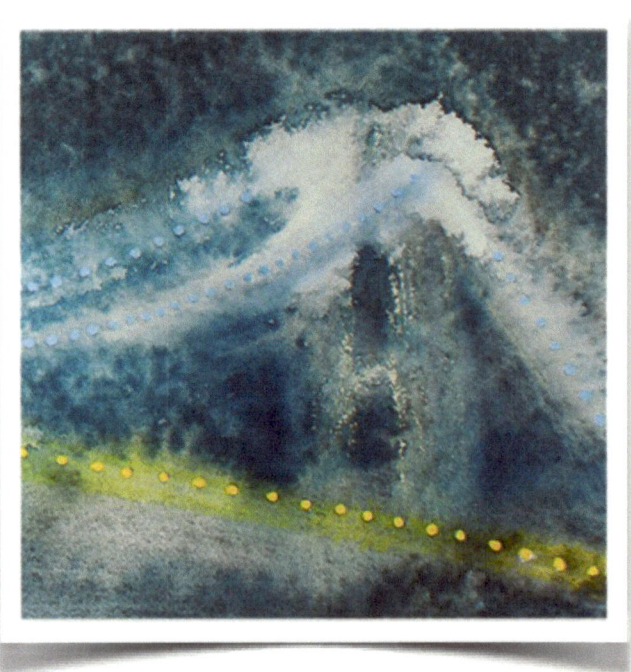

Alfred Martinez

George Washington Bridge in Winter, 1996
Watercolor on paper
22" x 30"

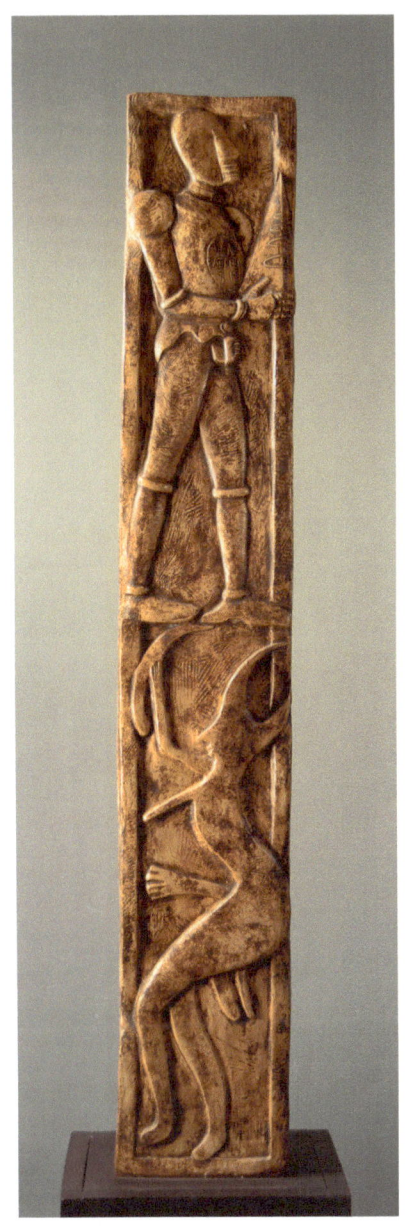
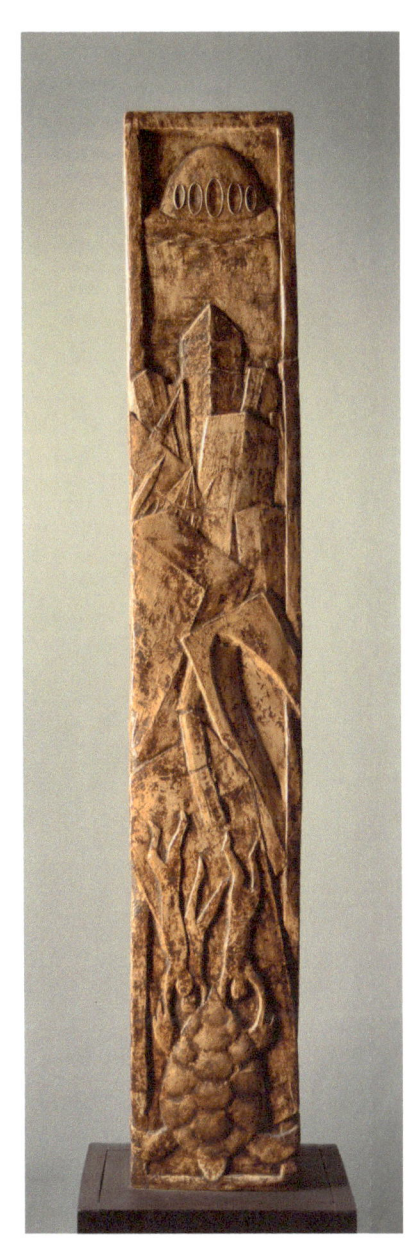

Front Back

Janice Mauro

Elite Tablet, 2012
Hydrocal
38" x 7" x 3"

Stephen McKenzie

Pele, the Fire Goddess, Plays with Her Lover, 2015
Screen and Relief Print
18" x 15"

Gail Miller

*Threads of Thought
on a Beautiful Universe*, 2019
Watercolor on archival paper
with hand sewing
12" x 12"

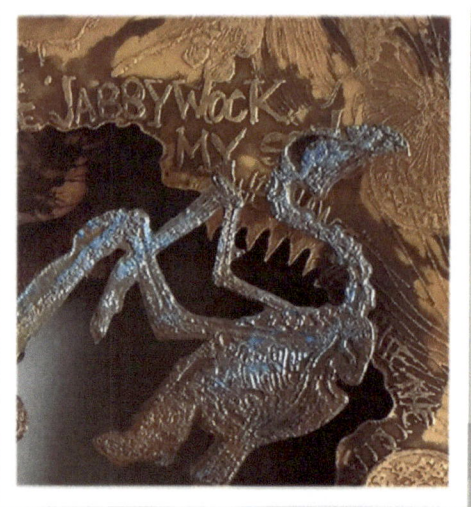

Chuck Miley

JABBERWOCKY, 2018
Brass, copper, gold leaf, patinas
9.25 " x 12 "

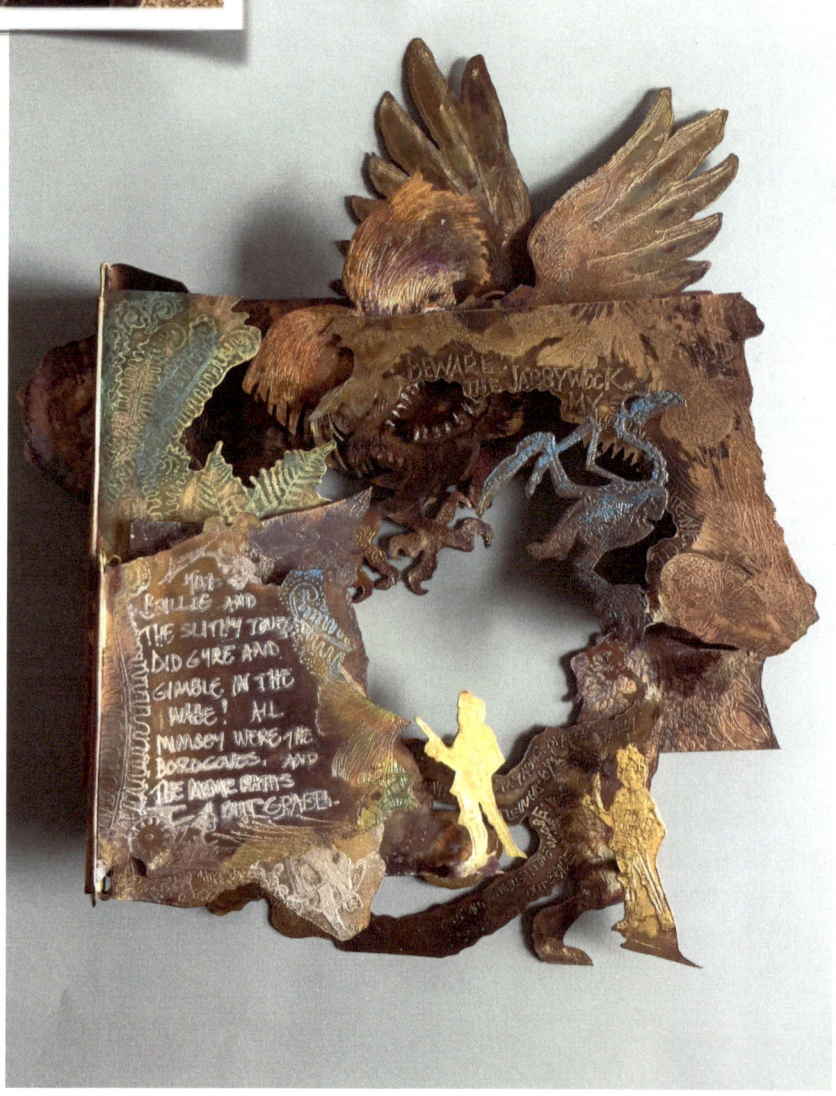

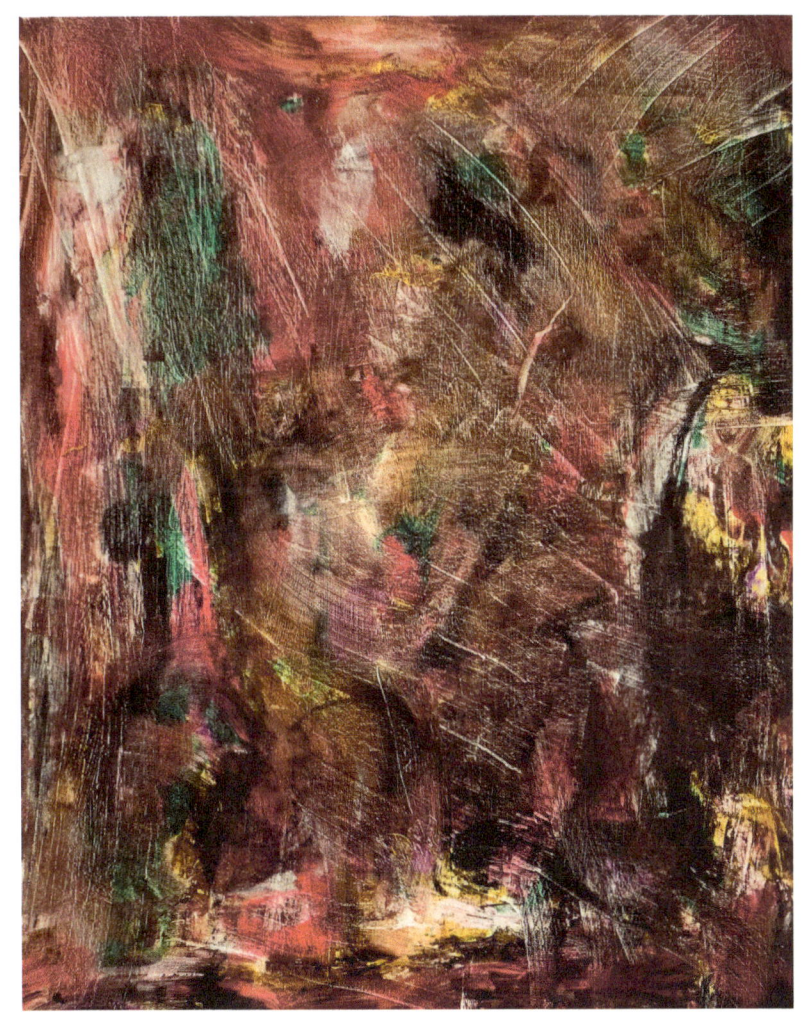

Fritzner Mervilus

Eye of Ra, 2019
Acrylic on canvas
20" x 16"

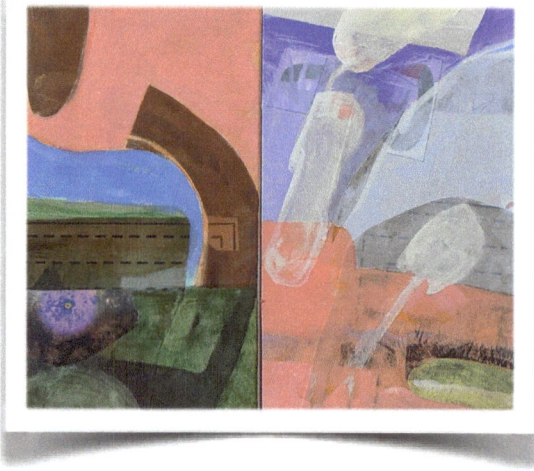

Mark V. Mellinger PhD

Patriarchs
Triptych: Abraham, Isaac, Jacob, 2019
Acrylic and collage on canvas
40" x 16" each panel

Annette Morriss

3.2.219, 2019
Charcoal on paper,
15" x 15"

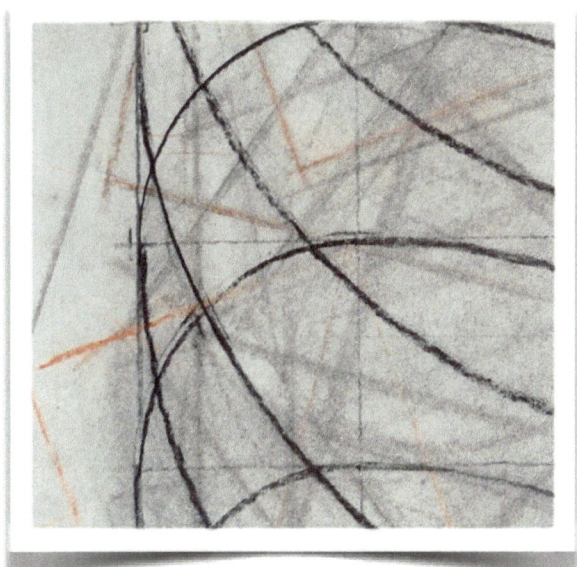

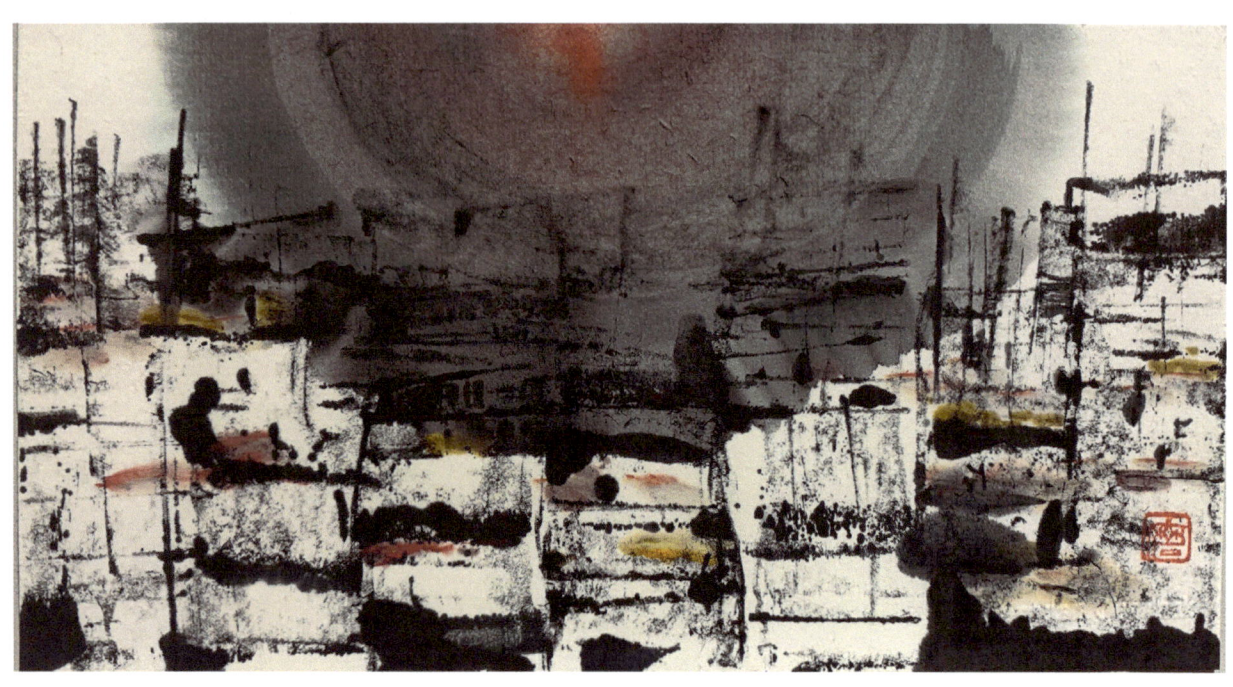

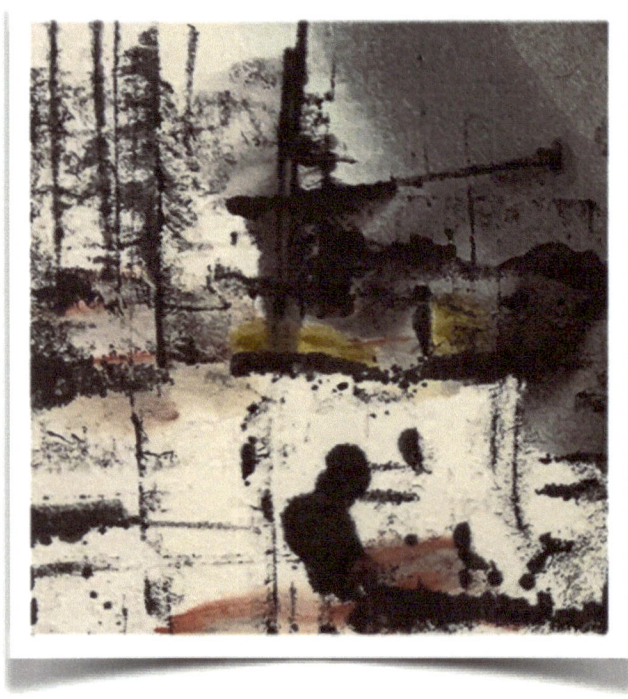

Margot Olejniczak

Sunset in the City, 2018
Ink and antique color
on Japanese paper
13.5" x 17"

Joanne Pagano Weber

The Play Station, 2006
Graphite on paper
15.62" x 11.75"

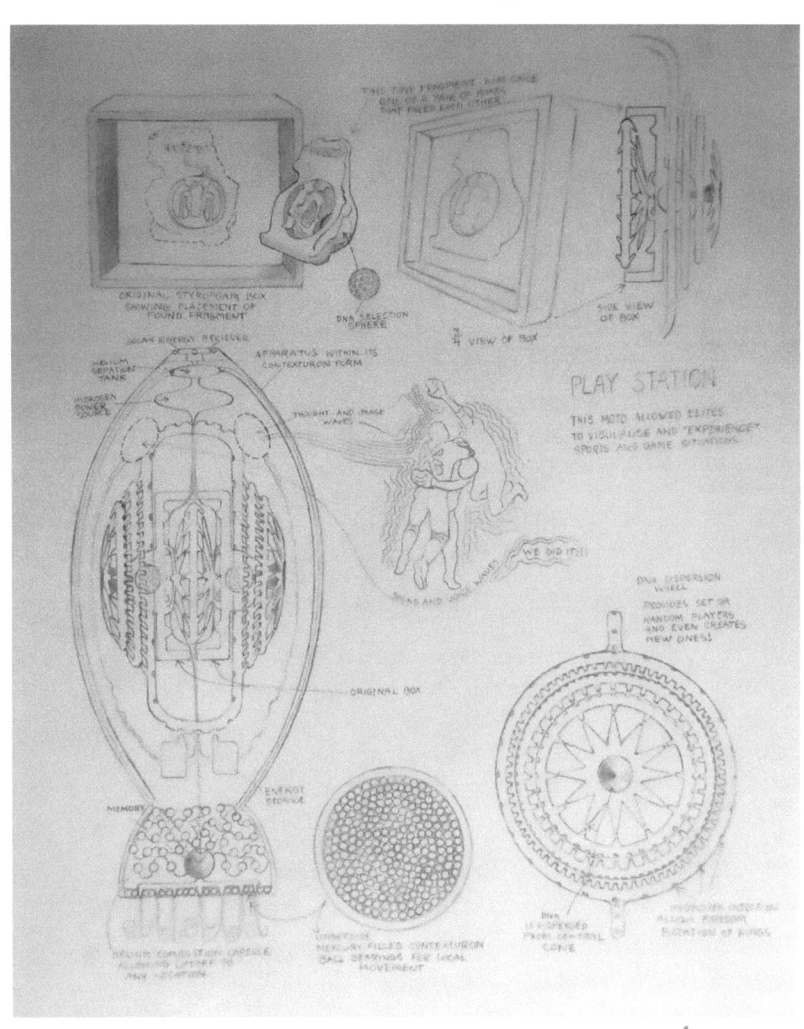

Ed Rath

The Birth of Venis, 2018
Acrylic on canvas
30" x 12"

Glenn Reed

Elevation 55, 2019
Epoxy resin, rice paper and steel
74" x 21" x 22"

Nicolette Reim

Sock with Orange Stripe, 2019
Print Media Collage
23" x 18"
2019

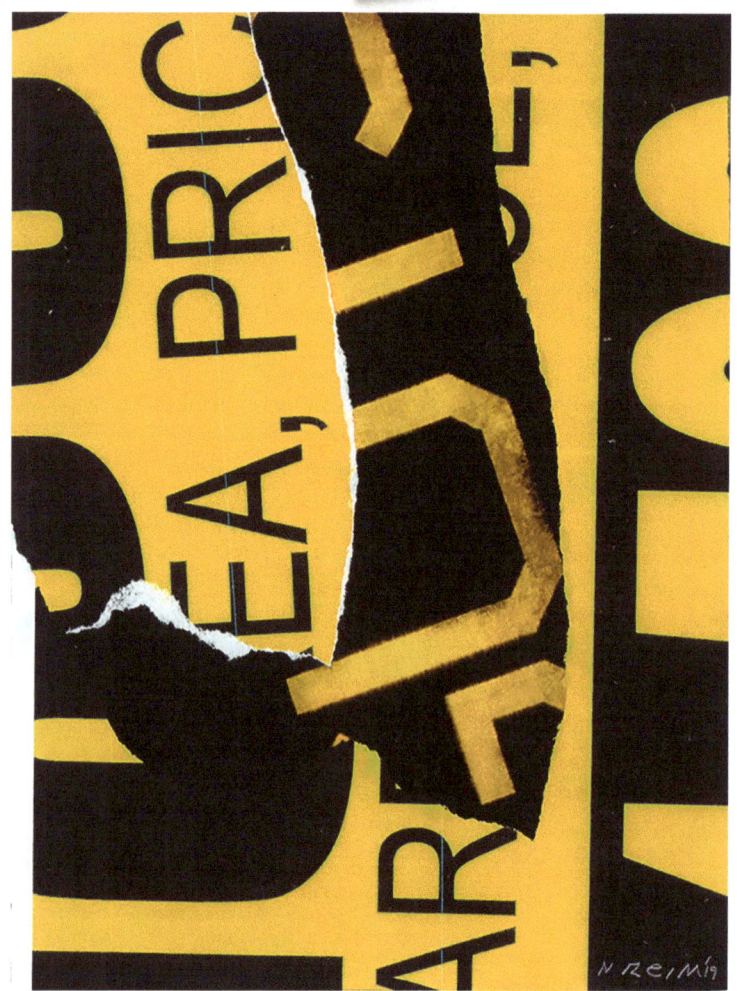

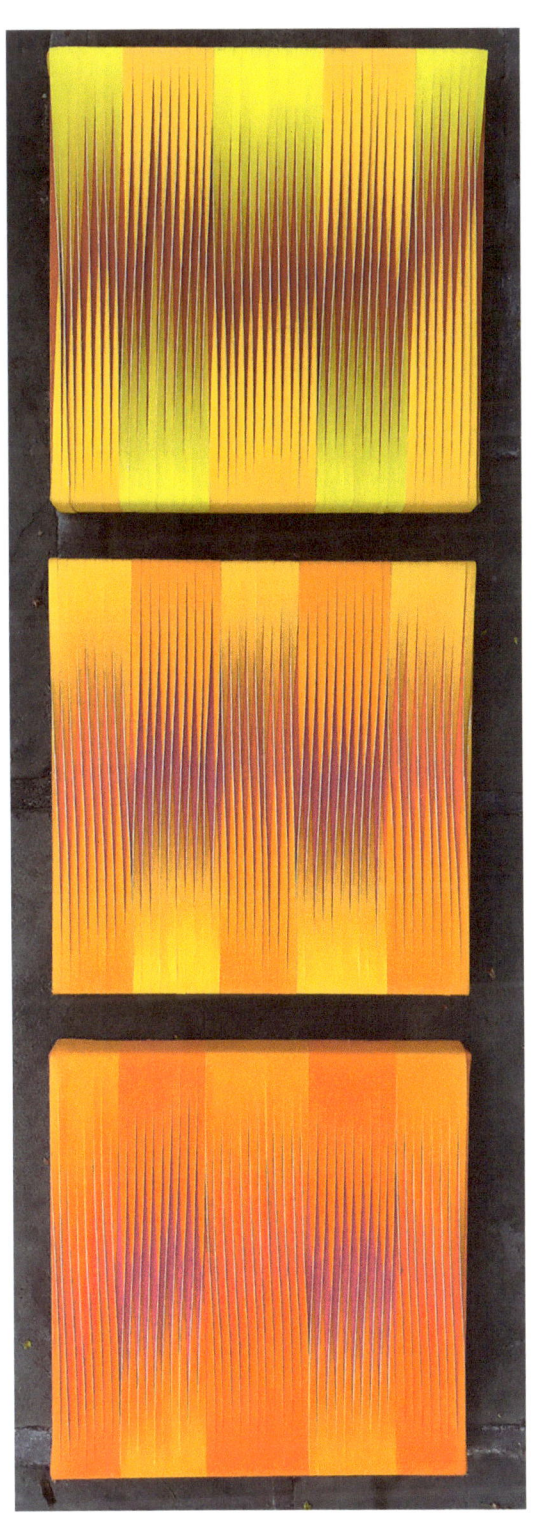

Gail Resen

Juicy 1, 2, 3, 2016-2019
Cut canvas, acrylic paint
12" x 12" each

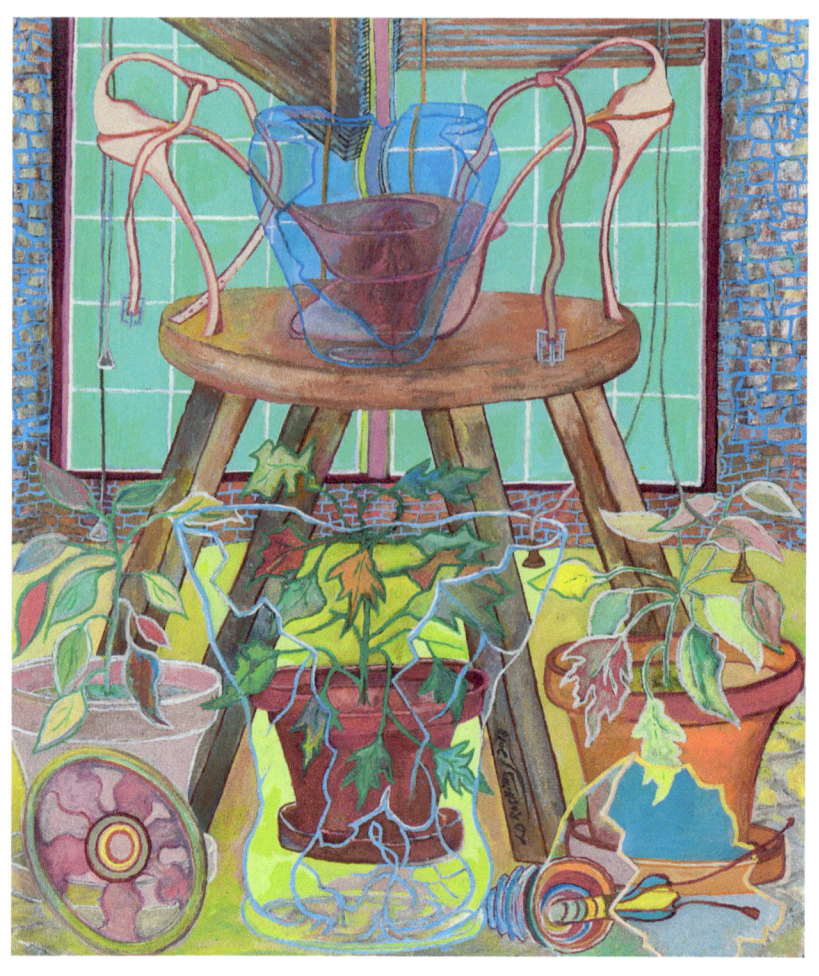

Larry Rushing

Three Point Two, 2018
Oil on Linen
22.75" x 20"

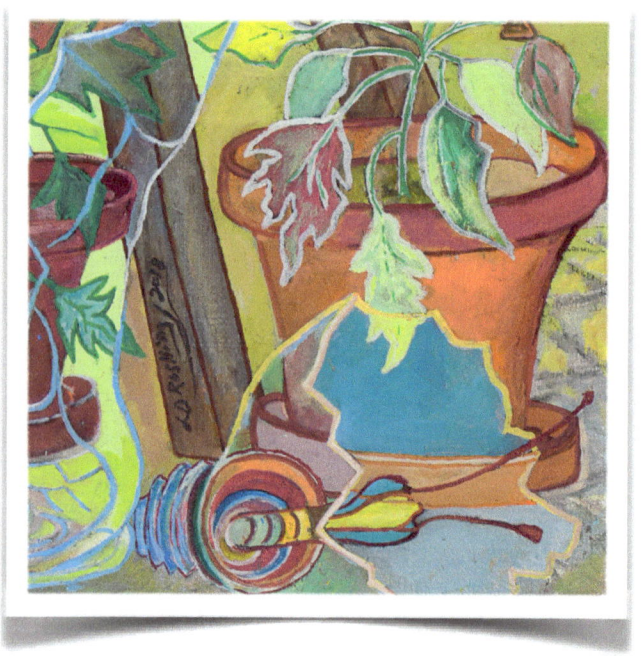

Judy Russell

Western Tanager, 2017
Acrylic on masonite
16" x 19"

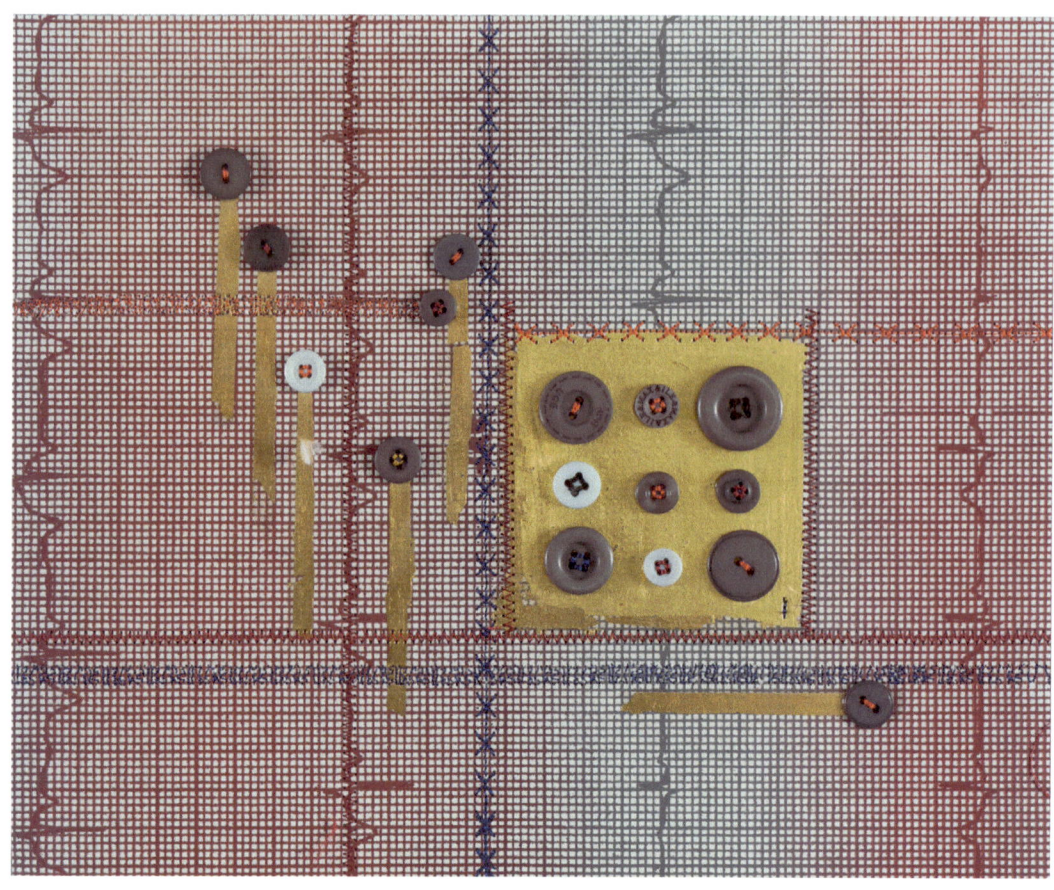

Larry Schulte

Button Up Your EKG, 2017
Screenprint with gold leaf,
machine stitching
and buttons
10" x 12"

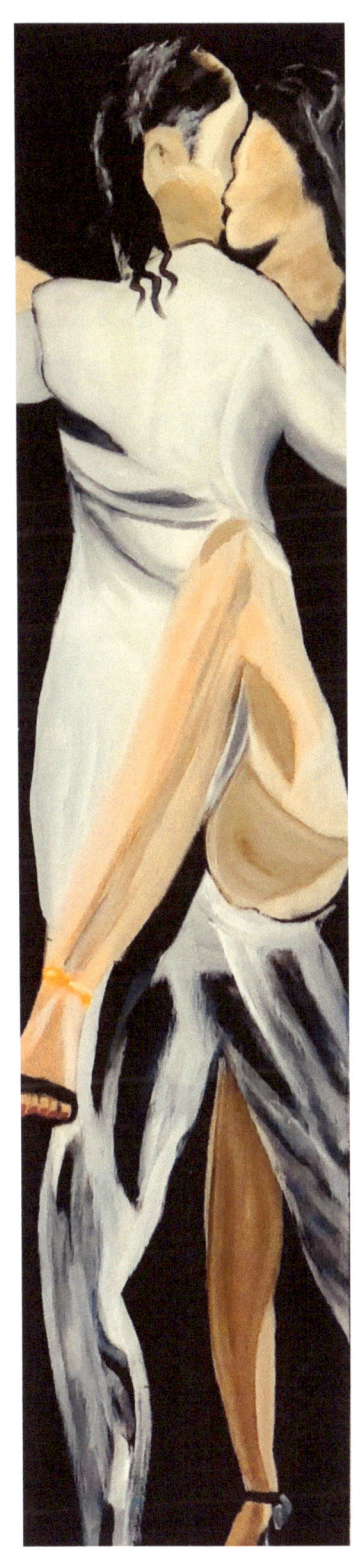

Donald Silverman

Tango Two, 2018
Oil on wood
6' x 11"

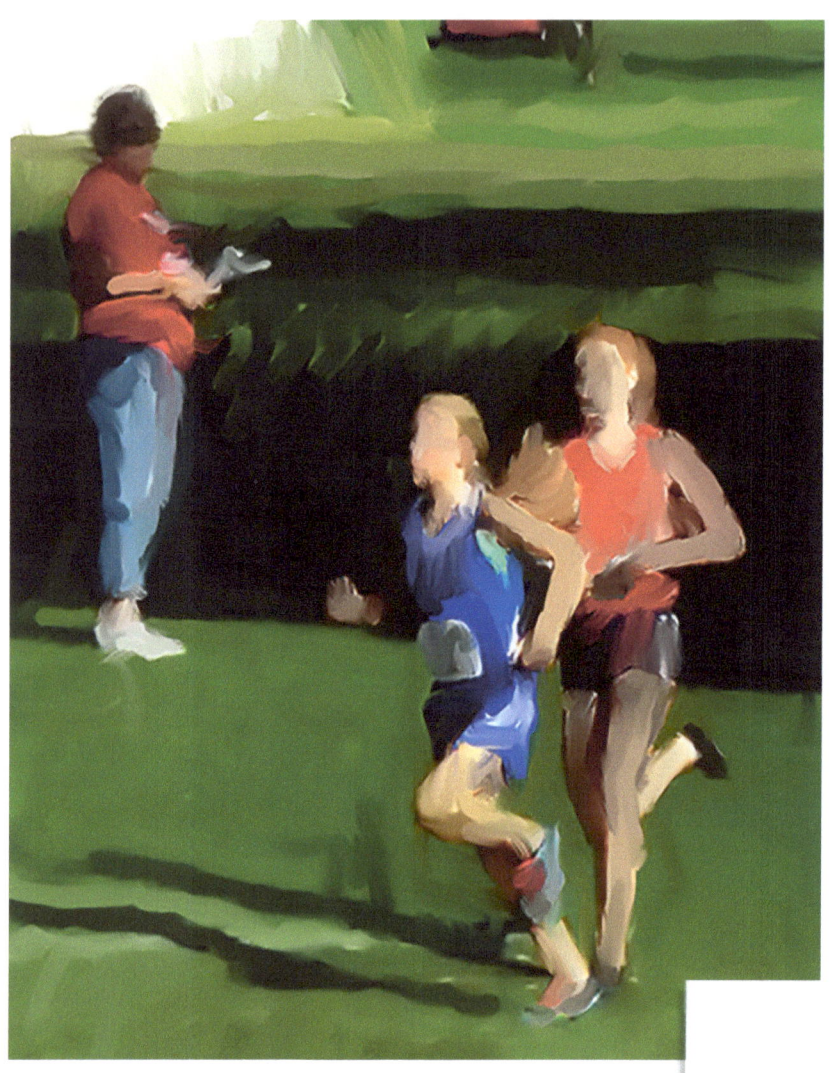

Harry Spitz

Cross Country Runners, 2019
Limited addition digital print
21" x 16.5"

Melissa Starke

Untitled Collage Study #16, 2017
Mixed media on canvas
12" x 9" each

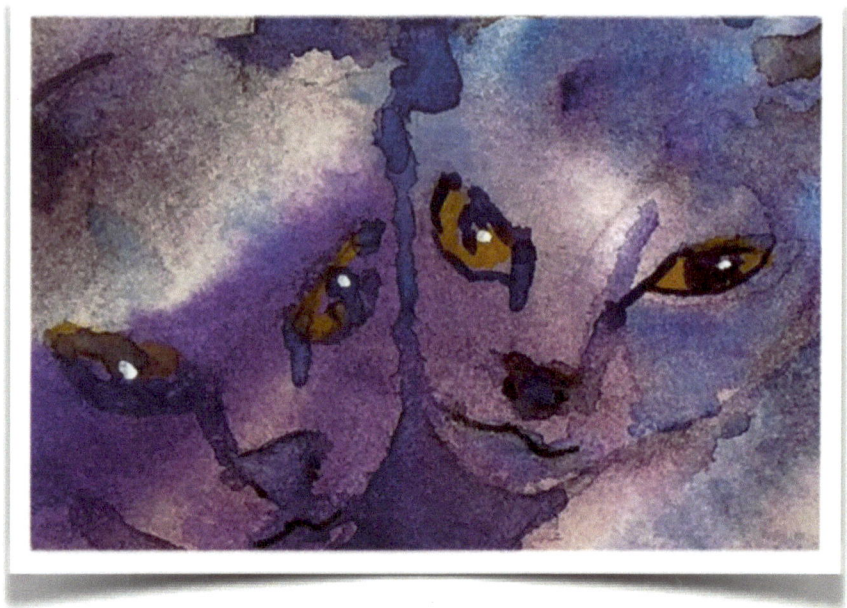

Emily Stedman

Twins, 2017
Watercolor on paper
14" x 16"

Margaret Vickers

LADY WITH HIPS, 1971
Ceramic
27" x 12"

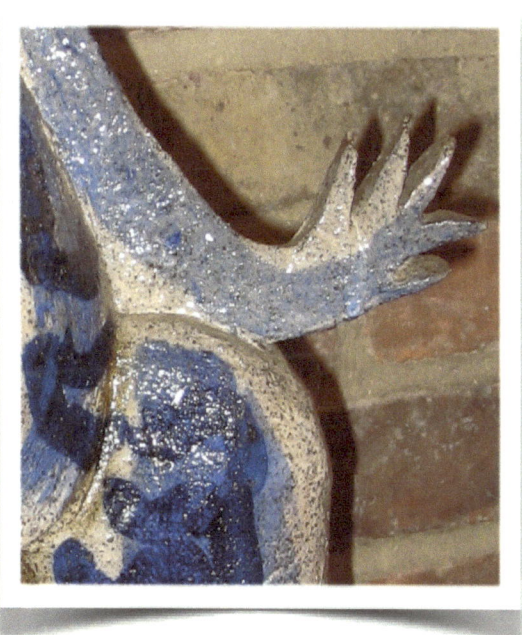

Martine Villandre

Untitled #3
Acrylic on canvas
29" x 16"

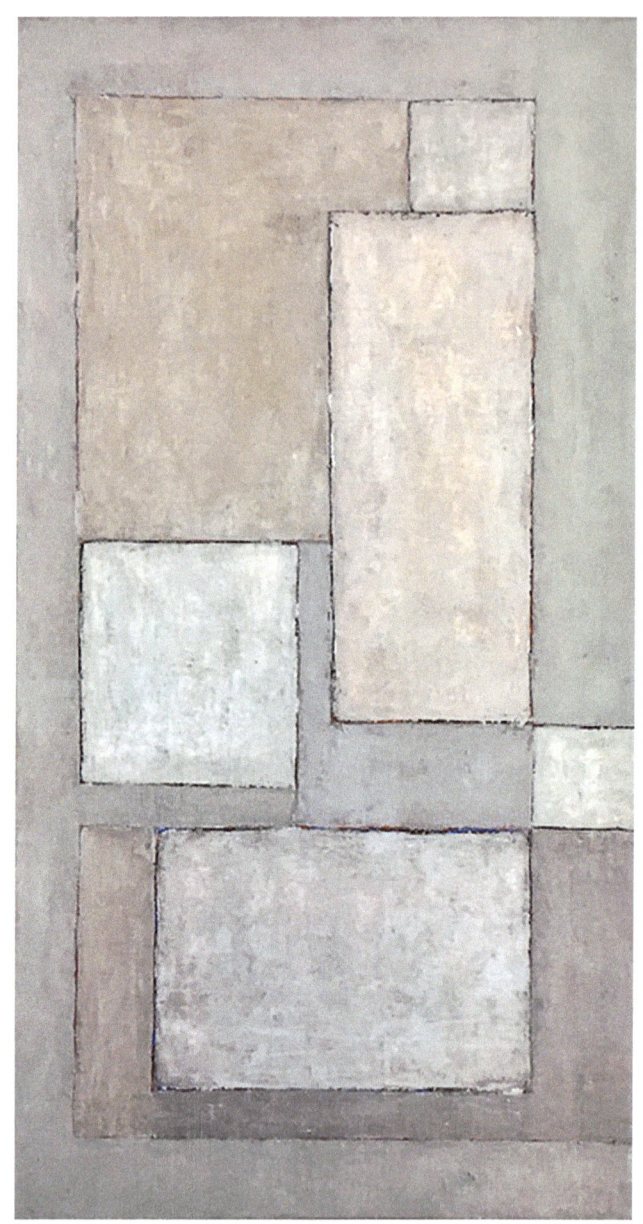

Hiroko Wada

Dizzy's, 2019
Pigment, gold leaf, collage on jute
9.45" × 13.78"

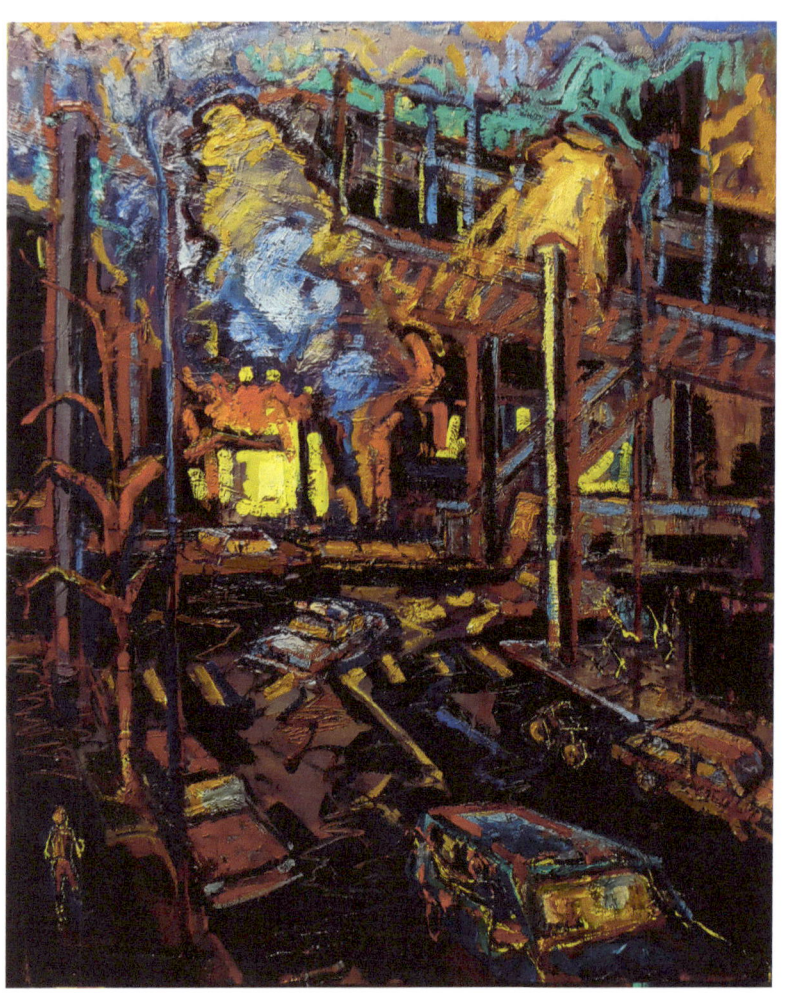

Kevin Wilson

Night Light, 2019
Oil on Canvas
24" x 20"

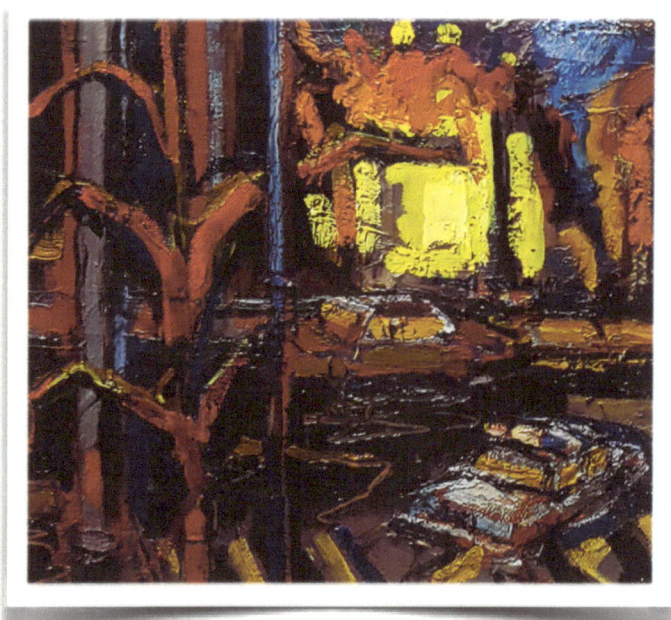

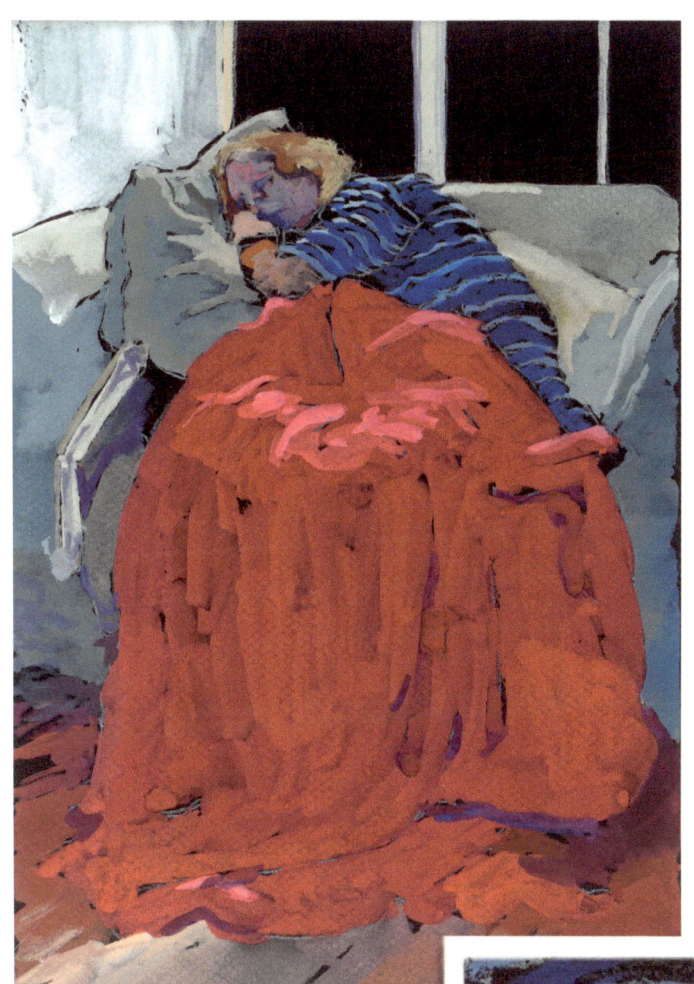

Tony C. Wilkinson

Red Blanket, 2009
Gouache
7.25" x 10.5"

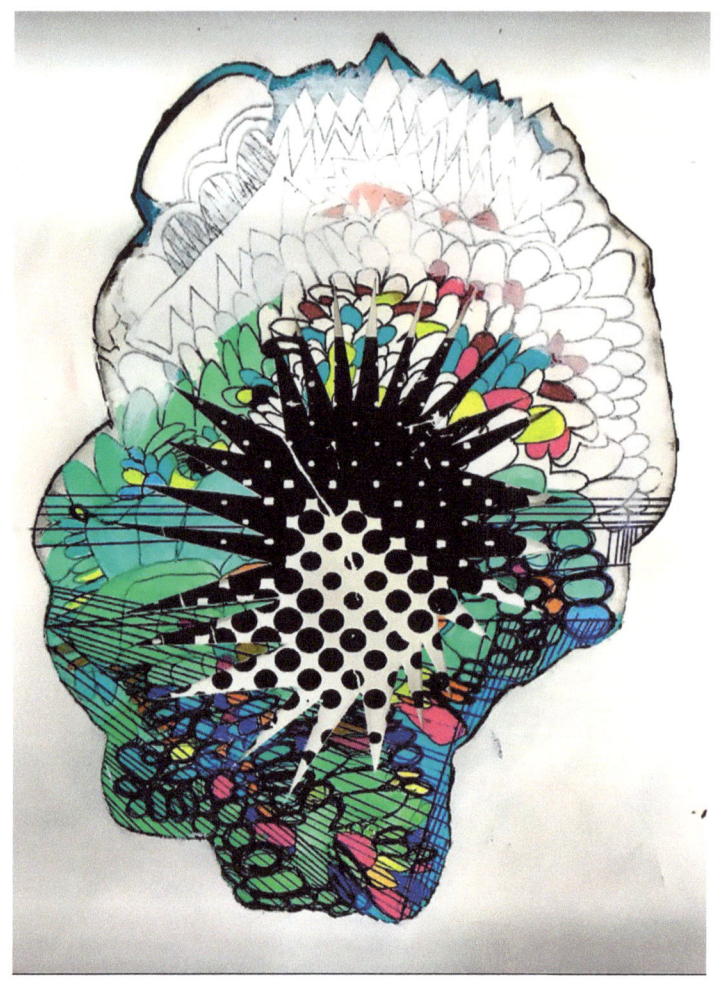

Marcin Wlodarczyk

Iguana, 2019
Solar plate, silkscreen, acrylic paint, ball pen ink
15" x 15"

Saaraliisa Ylitalo

Light Gets In, 2019
Hand made paper,
Indigo dyed, gold leaf
24" x 20"

Leon Yost

Piazza del Santo, Padua, Italy, 2005
Photo-assemblage
16" x 15"

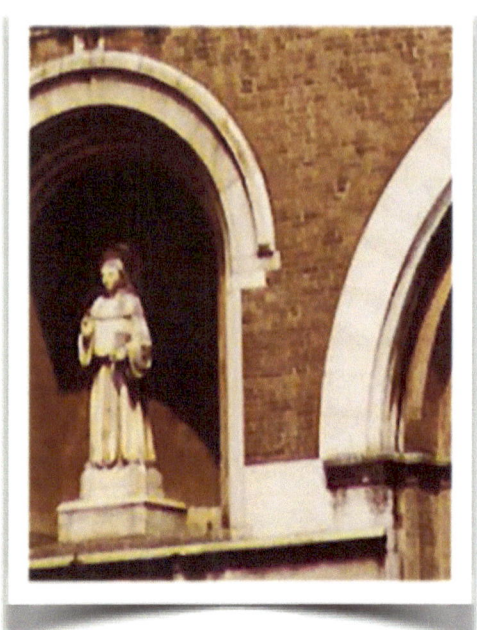

Copyright ©2019 by Noho M55 Gallery
The contributing artists retain sole copyright of their work.
Sponsored by 55 Mercer Street Artists, Inc.

Images from 3d Annual Invitational Exhibition
June 25 - July 13, 2019

Noho M55 Gallery
530 West 25th Street 4th Fl
New York, NY 10001

212 367 7063
noho.m55@gmail.com
nohogallery.net
55MercerStreetGallery.com

Instagram: @Noho.M55.Gallery
Facebook: M55 Art

Cover and book design: M. Winterdale

www.ingramcontent.com/pod-product-compliance
Lightning Source LLC
Chambersburg PA
CBHW041315180526
45172CB00004B/1106